art & ceremony

yilpinji

love art & ceremony

yilpinji

love art & ceremony

Christine Nicholls • The Australian Art Print Network

CRAFTSMAN HOUSE

Yilpinji, ngulaji yangka kujakalu watingki yunparni yampirrirla yangka kujakalujana karnta waninjaku ngurrju-mani watingki, yangka kujakalujana karnta panujarlu waninja-waninja-jarri watikari-watikariki,yangka yilpinji-warnuku jintakari-mirnimirnikarikinyanu yilpinji-warnukuju.
● ...Yilpinji, that's when men sing in the men's [ceremonial] area in order to make women fall in love with them, and as a consequence many women do fall for men [fall in love with one another] – as a result of these powerful 'yilpinji' ceremonies. ● ... Watingki kanyanurla yilpinji yunparni karnta nyanungu-nyanguku waninja-warnuku. Manu karntangku-yijala kanyanurla yunparni yilpinjirli watiki waninja-warnuku. ● ...A man sings Yilpinji love songs to attract a lover, in order to make a [particular] woman fall for him. And equally, a woman will sing a Yilpinji love charm, causing a man to fall in love with her. ● ...Waninja-warnu, ngulaji yangka kujaka-pala-nyanu karnta manu wati waninja-jarri, yangka kujaka-pala-nyanu wardupinyi miyalurlu, kurturdurrurlu, manu pirlirrparlu kanunjumanyumparlu – yapajarrarlu. ● 'Waninja-warnu', that's like a man and a woman falling in love, when two people feel attraction for one another in the pit of their stomachs, with their inner feelings, spirits, hearts and souls. – Paddy Patrick Jangala ● Sun, sky, stars, land, plants, animals, waterholes, bush tucker, dots, circles, and a certain cultural and spiritual 'ambience'... Australian Aboriginal art has become internationally celebrated for its depictions of 'country', that is the Australian landscape, environment and aspects of the natural world – whether these be encoded in the famous 'aerial views' of Western and Central Desert 'dot and circle' artists, or the more figurative works on bark by Arnhem Land artists. ● Collectively, these Indigenous artworks have functioned as a kind of wake-up call for many non-Aboriginal Australians, opening our eyes to the idea that the so-called "Great Australian Emptiness" is only a myth. ● For the Indigenous people of countless generations before British colonization, every square centimetre of country was teeming with life and spiritual energy, and imbued with cultural meaning. ● The Yilpinji collection shown here reinforces this truth, as it relates to an integral part of Aboriginal spiritual and cultural life, the so-called area of 'Love Magic'. ● The belated recognition of the creative, cognitive and spiritual energy of the Australian Aboriginal people has been immensely important for Australia as a nation. But Australia, like other nations, is a work-in-progress, and such recognition is only one stage of a much lengthier process. ● Aboriginal art exhibitions, whether 'blockbusters' or more modest shows, have played a significant role in the process of coming to terms with Aboriginal 'ways of seeing' the land we now share.

Such recognition of alternative ways of seeing and being-in-the-world has had flow-on effects. Today, the majority of Indigenous art exhibitions in Australia are organized on a regional basis, or show works by 'celebrated' individual Indigenous artists.　● 　Many exhibitions of Indigenous art are also founded, often unconsciously, on the binary logic of 'traditional' versus 'contemporary' or 'urban' Indigenous artists. Ultimately, this is an unsatisfactory view because all living human beings, regardless of background, comprise some elements of the 'traditional' and the 'contemporary'.　● 　Other recent Indigenous art exhibitions have been based on broadly political themes – for example, Indigenous prison art, or art that highlights the politics of continuing Indigenous social exclusion from Australia's dominant culture. Such exhibitions are of course entirely valid. An important part of non-Aboriginal Australians' collective learning curve has been to recognize the high of regional diversity of Indigenous Australian art, and the facts of the case about contact history, and about the continuing unacceptably high rates of incarceration of Indigenous men and its socially disastrous consequences.　● 　But in terms of curatorial approaches it's time to move on. While it's true that a good deal of Aboriginal art is about 'location, location, location' it also traverses a wide thematic range. Only rarely have Indigenous art exhibitions been presented according to a specific theme, recent exceptions being a study of colour in Indigenous and other Australian art and another loosely on thematically based 'Indigenous science.'　● 　While these are broad categories or themes they do represent a more nuanced approach to the content of Indigenous Australian art than many earlier indigenous art exhibitions, which have tended to position Aboriginal people as belonging to nature, as natural, rather than cultural beings. This taps into surprisingly resilient earlier Rousseau-esque beliefs that Aboriginal people are 'children of nature' (and by implication, *not* culture).　● 　Members of Australia's dominant culture have found it difficult to get our heads around the idea that a group of people may be unlettered and materially poor whilst simultaneously rich in terms of cultural capital, possessed of a sophisticated oral literature.　● 　Such ideas are perpetuated by certain writers and academics who erroneously claim, for example, that Aboriginal people did not or do not have words in their lexis for those emotions pertaining to the 'finer' feelings including love, fellow feeling and compassion for others.

The proposition that concepts and words for the sentient powers do not exist in Indigenous languages is quite untrue, but the ways in which these emotions are encoded linguistically in Indigenous languages differ significantly from European thought, to the extent that amateur linguists often have had difficulty in identifying such vocabulary.
● The politics of translation plays an important role here. Equally poorly understood, it seems, is the concept of Indigenous 'love magic', itself a reductive, sloppy translation of a complex cultural genre that has important social implications for Indigenous people. Nowhere was this more apparent than in Australian director Charles Chauvel's celebrated film *Jedda*, made in 1955 and seen around the world. ● While the so-called 'Love Magic' does exist in traditionally-oriented Indigenous Australian communities in a variety of different ways, including visual art, ceremony, lengthy narratives, song and dance, its purpose seems to be widely misconstrued. Indigenous 'Love Magic' certainly does not give rise to unlimited expression of erotic opportunities, or 'free love' as in the Swinging Sixties, but rather acts as a form of Indigenous social control, channeling erotic desire into socially acceptable outlets that ultimately confirm the *status quo ante* of Indigenous Law and usual marriage conventions. ● The inadequacy of the rendition 'love magic' becomes readily apparent when it is pointed out that this is an umbrella translation for terminology from many different Indigenous Australian languages (in total numbering approximately 250 prior to colonization). For this reason, henceforward I will use the Warlpiri and Kukatja word, *Yilpinji*, untranslated, rather than the misleading English hocus-pocus version 'love magic'.
● So, why do Indigenous societies practise *Yilpinji*? In traditional Australian Aboriginal life, there was a rigid system of arranged or "promised" marriages, which to some extent continues to this day. Essentially, marriage was an economic arrangement transacted between families, normally excluding what we would now understand as 'romance'. *Yilpinji*, or socially authorized adulterous liaisons, which occur within a strict framework of rules, give scope for the expression of romantic feelings, and sexual love, without threatening the marriage system.
● However, it is quite clear that there is an inherent danger in *Yilpinji*-mediated relationships. Such unions could easily lurch out of control and therefore threaten normative marriage practices and rules. Hence the *Yilpinji* Dreaming narratives about illicit, transgressive love affairs, which act as warnings, as cautionary tales.

Opposite page; Clifford Possum Tjapaltjarri, c. 1934–2003; Man's Love Story; 1978, Mbunghera, near Papunya, Northern territory synthetic polymer paint on canvas; 216.5 x 260.5 cm; Visual Arts Board, Australian Contemporary Art Acquisitions Program, 1980; Art Gallery of South Australia, Adelaide.

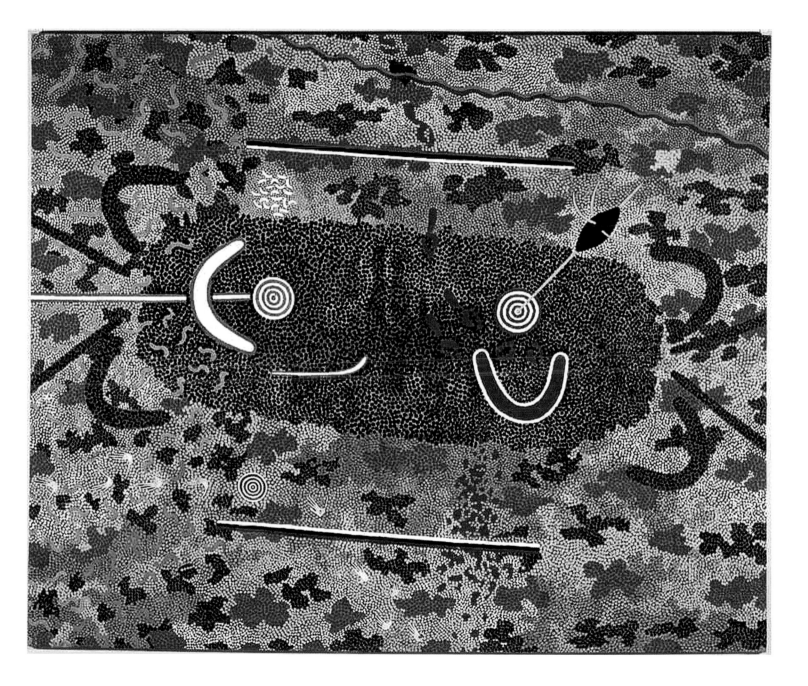

Women's Dreaming
Ronnie Lawson Jakamarra

t his is an important male Yilpinji (love magic) story. All Women, despite their devotion to the land they grow up in, must forsake this country and once married go with a man of the right skin group and adopt his country. The artist has shown a Jakamarra man and his Napaljarri partner as U shapes with their genitals protruding in the centre of the image. The woman is surrounded by digging sticks. The man is shown at the top of the image with his shield. They are both travelling from the south to the north. The woman wants to go toward her own country. Her desire to travel east is shown at the bottom of the image. However, the travelling lines are not connected to her destination indicating that the man is preventing her from returning to her country. She must go with him to his own country as indicated by the travelling path shown on either side of the image. He tells her, 'If you go that way, you will have to travel with another man of the wrong skin group'.

medium
Screenprint: Opaque paint on four acetates

edition size
99

collaborator/platemaker
Basil Hall

printer
Simon White

studio
Basil Hall Editions, Darwin NT

acetates created at
Lajamanu, July 2002

print published
Darwin NT, January 2003

paper
Magnani Pescia 300gsm

paper size
760 mm x 560 mm

image size
640 mm x 480 mm

AAPN ID #
RL004

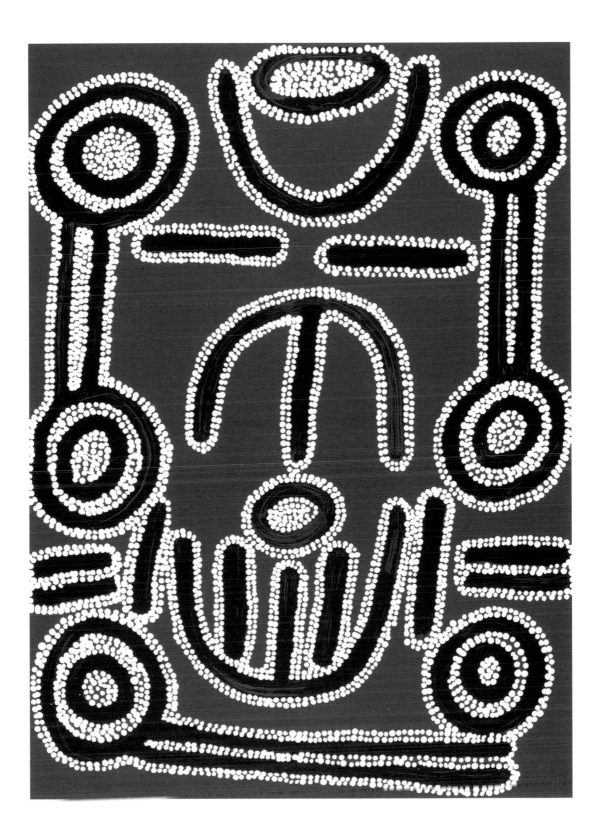

bai Bai, a senior law person, responded to the theme, Love, Magic and Ceremony by producing three images on linoleum which have been integrated into a single print in sequence from top to bottom. The top section represents Ngaanjatjarra, her grandmother's country, which is located south west of Balgo in the Great Sandy Desert, where she lived and hunted as a young woman. The Tjukurrpa story for this place tells of some wicked young men who came here far from the west looking for young girls. The old woman responsible for this country wove a long hair string belt central to the top panel image, and used it to tie them up, so as to curb their sexual appetites. The second, central panel, is a series of brightly coloured fat, feathers, sand and material ephemera used in an important ceremony. These lines also represent the *tali* or sand hills which dominate Bai Bai's country. The third, bottom panel, is another image of Ngaanjatjarra showing the elongated soak surrounded by *tali* or sand hills. In a second level of meaning it depicts women participating in a ceremony around a dance field representing the soakwater. Sand hills radiate out in the surrounding country.

medium
Screenprint from
linoleum blocks

edition size
99

printer
Theo Tremblay

studio
Editions Tremblay NFP,
Bungendore ACT

lino blocks created
Warlayirti Artists,
Balgo Hills WA, June 2002

print published
June 2003

paper
Magnani Pescia 300gsm

paper size
760mm x 560mm

image size
760mm x 560mm

AAPN ID #
BN003

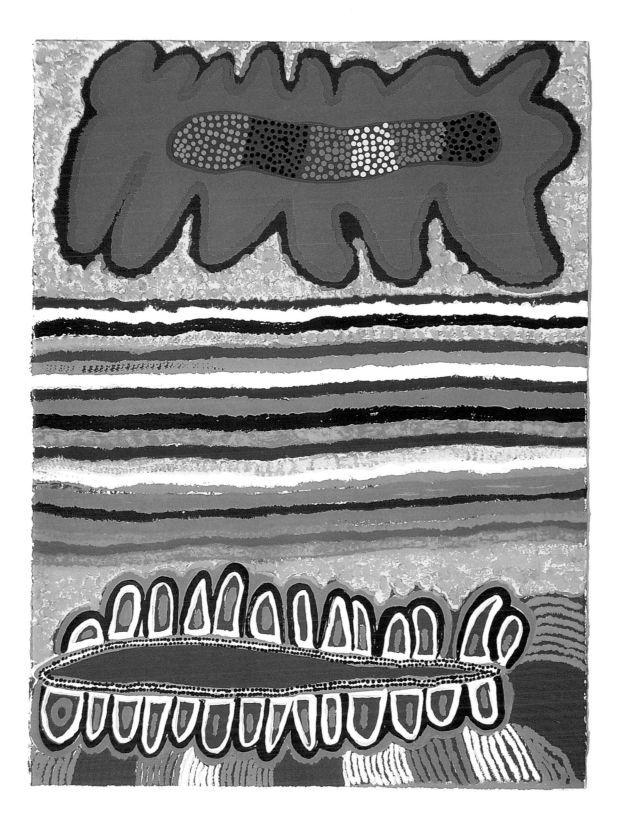

Rosie Tasman Napurrurla First Love

t he woman makes a *majardi*, love belt, and sings her love spell into it. She knows that once her man puts the belt around her waist he will think of himself as her lover. The woman brings it for the man to put around her waist. She takes up her digging stick and her lover grabs his shield and they run away together into the bush.

They light a fire and lie alongside one another as boy friend and girl friend. Other people gather, looking around the bush for the lovers. They run away but are seen travelling along together as a couple.

Wiparn-manu wajankujulu, ngulajangkarna yanurnu manyu-kurralku. You have drawn me in and that's why I've come to take part in the 'business'

medium
Screenprint: Opaque paint on four acetates in two versions (black and red ochre backgrounds)

edition size
99

collaborator/platemaker
Basil Hall

printer
Simon White

studio
Basil Hall Editions, Darwin NT

acetates created at
Lajamanu NT, July 2002

print published
Darwin NT, November 2002

paper
Magnani Pescia 300gsm

paper size
760mm x 560mm

image size
680mm x 480mm

AAPN ID #
RT015

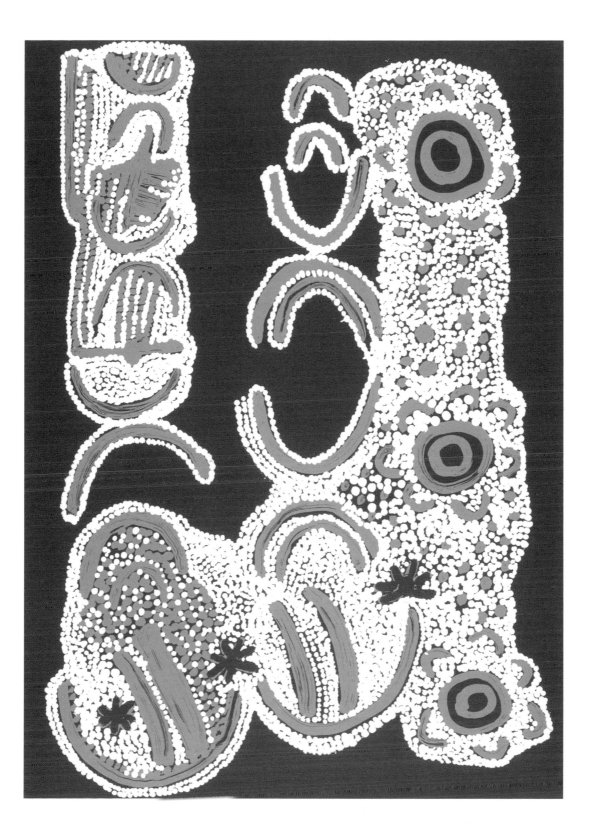

Eubena Nampitjin

'nakarra' is a familiar version of the Kukatja kinship term, "Nakamarra", a female 'skin' (kin) name that is often used as a form of address. It is also a children's form of the skin name Nakamarra. Plurals in the Kukatja language (and in Warlpiri) are sometimes formed by reduplication, ie simply by doubling the singular version of the noun/nominal. Hence 'Nakarra Nakarra' implies more than one girl or woman, who all share the skin-name 'Nakarra'. In this particular instance there are seven girls/ or young women with the same skin-name Nakarra. They are sisters. In fact, these young women are The Seven Sisters – the Pleiades. There are many interesting things about this Tjukurrpa or Dreaming narrative. For instance, in terms of cross-cultural crossovers, interestingly enough in Greek mythology this cluster of brilliant stars is also thought to comprise seven sisters, believed to be the seven mythical daughters of Pleione and the legendary Atlas. Another is the fact that it reveals Indigenous people's detailed knowledge of astronomy as well as the strict moral codes within which they operate. There are many different versions of this Seven Sisters Dreaming narrative throughout Aboriginal Australia that are sung and painted. This story and artistic representations of it extend as far south as the Ngarrindjeri people of the River Murray in South Australia.

(Continued on page 84).

medium
Original Screenprint

edition size
99

printer
Theo Tremblay assisted
by Barak Zelig

studio
Editions NFP,
Bungendore NSW

accetates created at
Warlayirti Artists,
Balgo Hills WA,
June 2002

print published
Bungendore NSW, June 2003

paper
Magnani Pescia, 300gsm, white

paper size
760mm x 560mm

image size
700mm x 530mm

AAPN ID #
EN002

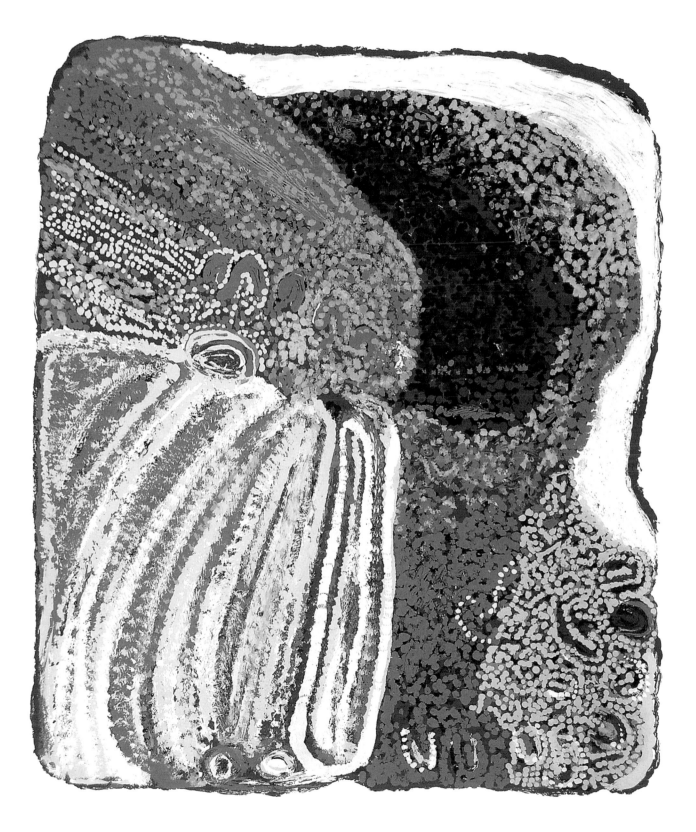

t his is another version by Eubena Nampitjin of Nakarra Nakarra II Seven Sisters Dreaming. At the core of the narrative are the Seven Sisters, Creator Beings who move around country, creating natural phenomena and involving themselves in ceremonial life, including "young men's business" or initiation ceremonies. A man who has 'got the hots' for these gorgeous young women is chasing them across the country. This man is in the "wrong skin" relationship to the sisters and therefore is not a suitable marriage partner for them under Kukatja law. In fact such a union is considered incestuous and therefore very wrong. The man's pursuit of these nubile young women is permanently "engraved" onto the night sky itself in the form of the cluster of stars known in English as The Seven Sisters.

(Continued on page 84).

medium
Original Screenprint

edition size
99

printer
Theo Tremblay assisted
by Barak Zrlig

studio
Editions NFP, Bungendore NSW

accetates created at
Warlayirti Artists, Balgo Hills WA,
June 2002

print published
Bungendore NSW, June 2003

paper
Magnani Pescia, 300gsm, white

paper size
760mm x 560mm

image size
420mm 360mm

AAPN ID #
EN003

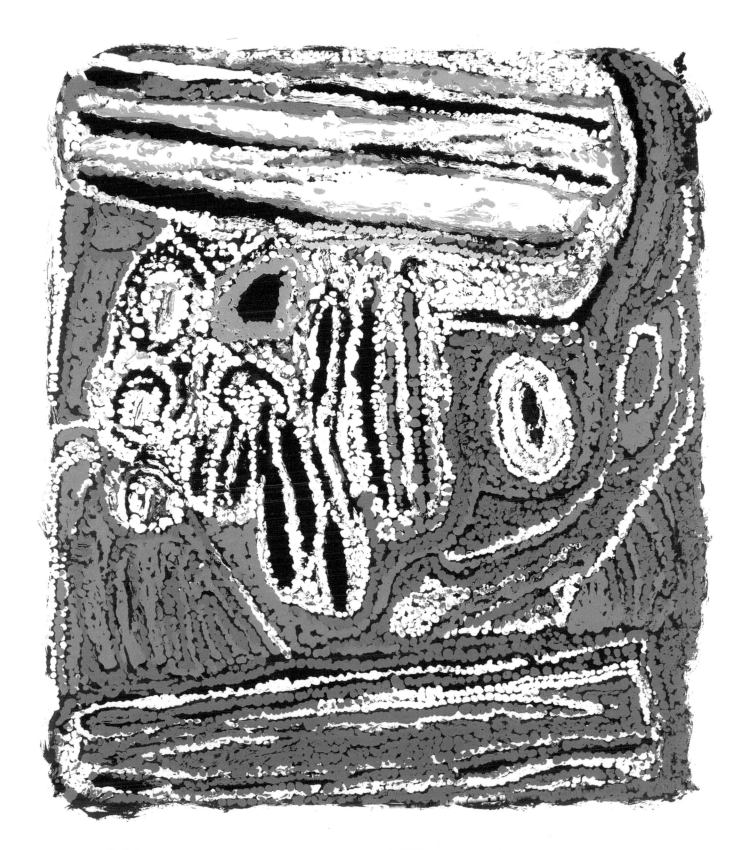

t he artist was, until his death, the most senior Warlpiri man for this Jukurrpa (Dreaming). This Rain story provides the scenario for many Warlpiri Yilpinji (love magic songs). Abie's image shows body adornment designs used to represent Ngapa (water, rain). Pairs of parallel lines representing clouds surround two rainbows (long wavy lines). Amongst their neighbours, the Kaytej people, these symbols represent the two Rainbow Men. Diane Bell, in her seminal book, 'Daughters of the Dreaming', explains that in the narrative the wise rain father, known as Junkaji, attempts to restrain his overly pretentious sons the Rainbow Men. The boys come in to conflict with their older brother, Lightning, while pursuing young girls to whom they are incestuously related. Rain's wife, the mother of the boys, finally lures them from the dangers of their exploits by feigning illness. Their duty to their mother overwhelms them and at the insistence of their father they return, only to die. Important themes of father/son authority flouted and mother duty/devotion/destruction are all revealed through the recounting of this Dreaming.

(Continued on page 84).

medium
Etching: Sugar lift painting and aquatint on one plate; embossing on second plate

edition size
99

collaborator/platemakrt
Basil Hall

printer
Matthew Ablitt

studio
Basil Hall Editions, Darwin NT

plate created
Lajamanu NT, July 2002

print published
Darwin NT, June 2003

paper
Hahnemuhle 350gsm

paper size
560mm x 760mm

image size
240mm x 640mm

AAPN ID #
AJ009

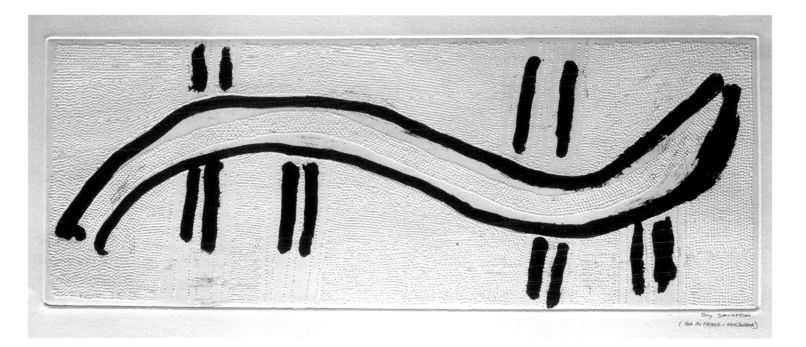

Tony Sampson
(For his Father - Ngajanena)

this print was made from the mark the artist made on an etching plate while telling the narrative story, which took place at Thompson's Rockhole in the Tanami Desert. The artist was only three weeks from the end of his life and unable to paint any longer. The marks are exactly as he made them as if drawing in the sand while telling an epic tale. Katinpatimpa was a Jangala. Two women fell in love with him at Thompson's Rockhole where they were living. The women were both Nungarrayis and their father was a Japaljarri. That Japaljarri gave his daughters to Katinpatimpa. The Jangala married them both, both of the daughters. The Rainman, Ngapa, came and hit him with lightning. Ngapa chased Katinpatimpa and struck him so he broke a leg, Katinpatimpa came back and took his two women to a Mulju (a soakage). That Mulju was called Yantukumanpa. Ngapa caught up with him there while he was digging for water. The two Nungarrayis told Katinpatimpa to get up and go. Ngapa chased him all the way back to Thompson's Rockhole. He put him in the water. They fought fiercely. Katinpatimpa kept moving as he fought all the way to Wulampi. Ngapa killed him there. He had deep marks across his body from the boomerangs that hit him and the spears that pierced his skin. He turned into a stone at that place. That stone is still there to this day.

medium
Etching: Sugar lift painting and aquatint and a la poupee inking on two plates

edition size
99

collaborator/platemaker
Basil Hall

printer
Matthew Ablitt

studio
Basil Hall Editions, Darwin NT

plate created
Lajamanu NT, July 2002

print published
Darwin NT, June 2003

paper
Hahnemuhle 350gsm

paper size
560mm x 760mm

image size
540mm x 740mm

AAPN ID #
AJ010

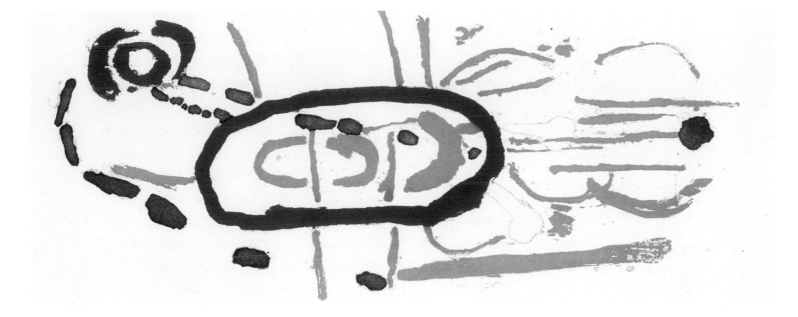

medium
Screenprint

edition size
99

printer
Theo Tremblay assisted
by Barak Zrlig

studio
Editions Trembley NFP,
Bungendore NSW

accetates created at
Warlayirti Artists,
Balgo Hills WA,
June 2002

print published
Bungendore NSW,
June 2003

paper
Magnani Incisioni,
300gsm white

paper size
560mm x 760mm

image size
335mm x 500mm

AAPN ID #
EN001

elizabeth, when asked about Love/Magic, depicted her father's country known as Parwalla. It is located far to the south of Balgo in the Great Sandy Desert, west of the community of Kiwirrkurra. The landscape of the area is dominated by *tali* or sand hills. Parwalla is swampy, filling a huge area with water after the wet season rain. These wet season rains result in an abundance of good bush tucker. Depicted here is *kanytjilyi,* or bush raisin surrounded by *tali* or sand hills. Both men and women collect bush raisins with each other. It is an activity said to bring men and women together. The bush raisin is high in protein and is thought to have beneficial healing properties for women's complaints.

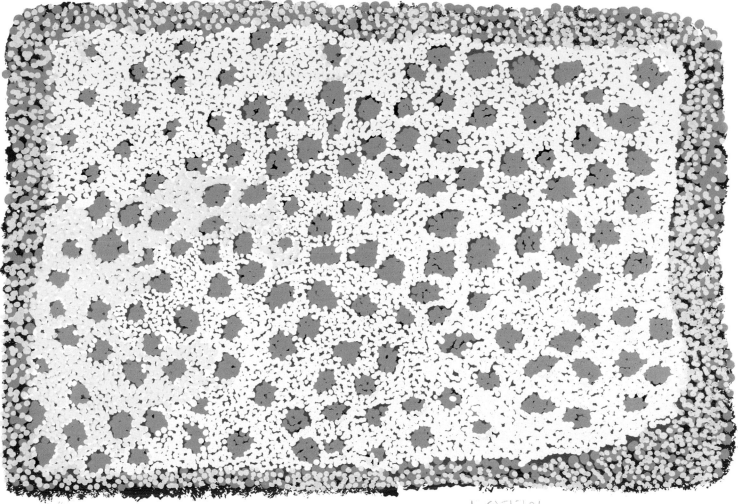

1/49 EGTT701

helicopter has painted some of his traditional country, which is located far to the south west of Balgo, in the Great Sandy Desert. This country is centred around Jupiter Well and is dominated by tali or sand hills. "These lines made by wind are *tali* (sand hills). *Kurli*, good wind, brings warm weather. Not rubbish wind, *yalta*, cold wind, maybe kill babies and old people. Lovely time of year, birds everywhere, everything growing, boys and girls running amok. This soak, living water, we call *yinta*, really full up when rains come. These white stones, *mawuntu*, special place; ceremony place."

medium
Hand wiped and rolled
eight colour relief print

edition size
99

printer
Theo Tremblay assisted by
Barak Zrlig

studio
Editions Trembley NFP,
Bungendore NSW

block created at
Warlayirti Artista, Balgo Hills WA
June 2002

print published
Bungendore NSW, April 2003

paper
Magnani Pescia, 300gsm white

paper size
760mm x 560mm

image size
760mm x 560mm

AAPN ID #
HT001

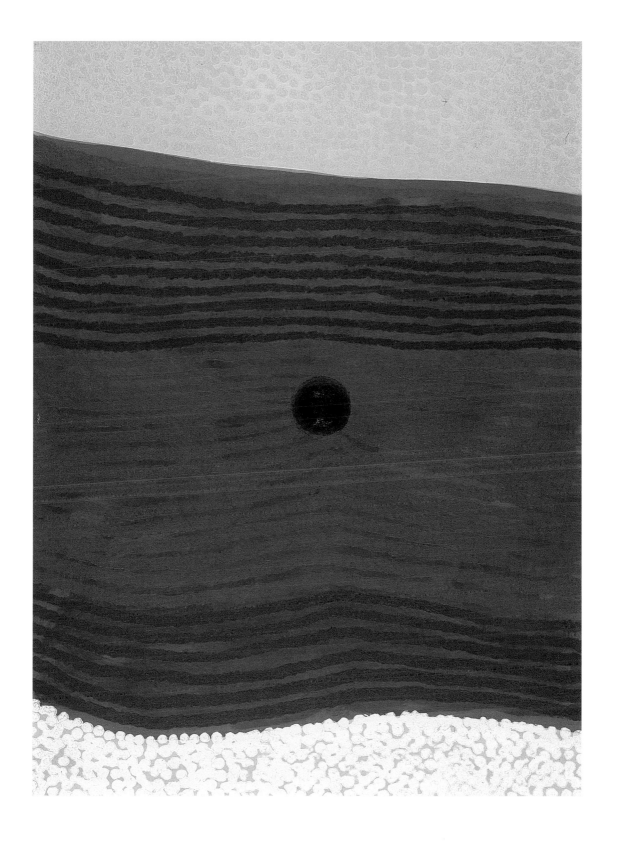

amongst the Warlpiri, women and men share many rituals, customs, Dreamings and practices involved in *Yilpinji*, Love Magic. This print by important Warlpiri artist Judy Napangardi Martin shows women (U shapes) making *Majardi*, Love Magic Hair Belts. Having fallen in love the girl goes to her female relatives and is instructed on how to attract a man as her lover. She weaves a belt while singing Yilpinji songs, imbuing the belt with magic.

(Continued on page 86)

Kinkirnangku pakarnu. I bewitched you, I fell I love with you. *Waninja-warnu, ngulaji yangka kujaka-pala-nyanu karnta manu wati waninja-jarri, yangka kujaka-pala-nyanu wardu-pinyi miyalurlu, kurturdurrurlu, manu pirlirrparlu kanunjumpanyumpa - yapajarrarlu.* Wanin-jawarnu is like when a man and a woman fall in love with each other, like when two people feel attracted to each other in their inner feelings, in their heart and soul.

medium
Screenprint. Opaque paint on three acetates

edition size
99

collaborator/platemaker
Basil Hall

printer
Basil Hall

studio
Basil Hall Editions, Darwin NT

accetetes created at
Lajamanu, July 2002

print published
Darwin NT, November 2002

paper
Magnani Pescia 300gsm

paper size
760mm x 560mm

image size
680mm x 485mm

AAPN ID #
JM006

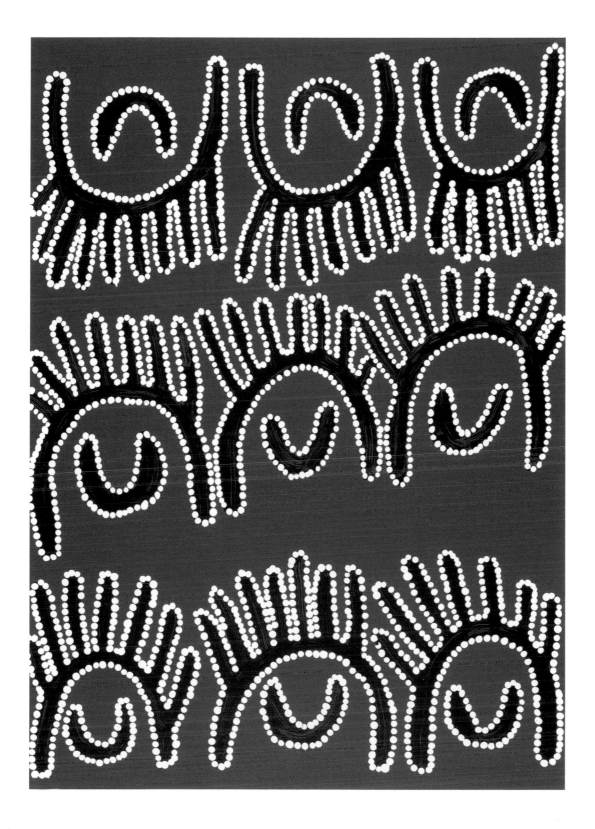

Love Story
Judy Watson Napangardi

at Mina Mina women were living and holding a women's ceremony. The Napangardi and Napurrurla women were weaving *Jinjirla* (flowers or other décorations) around their heads. The old man named Jarlkijarlki Jakamarra was watching them from his country Munyuparnti-parnti, near Mt Denison. So he went up to them and took them towards the east. Jakamarra took them to a place called Yaarlankirri that is in Alywarr Country. The Jakamarra was singing love songs for them and so he left them at Yaarlankirri, while he was singing he made the ladies put their hands behind their backs. The ladies stopped at this place called Yaarlankirri forever and that Jakamarra, Jarlkijarlki, came back to Munyuparnti-parnti. Before that Jakamarra man took the women East the women made a big wee at Munyuparnti-parnti and they made a big hole in the ground and this hole is called Munyuparnti-parnti. In this story also the Jakamarra man was rubbing his hand on his private parts so he could have all the women to himself.

Kajilpa karntarlangu marnpikarla yangka murnti ngarrkakurlangu, kajika ngarrka yangka purami tarnngangku. Kajikarla waninja-nyinamilki tarnnga.

If a woman, say, touches that love-charm belonging to a man, then she will always follow him. She will always love him.

medium
Screenprint.
Opaque paint on
seven acetates

edition size
99

collaborator/platemaker
Basil Hall

printer
Simon White

studio
Basil Hall Editions, Darwin NT

acetates created
Warlukurlangu Artists,
Yuendumu, May 2002

print published
Darwin NT, November 2002

paper
Magnani Pescia Black

paper size
760mm x 560mm

image size
760mm x 560mm

AAPN ID #
JW006

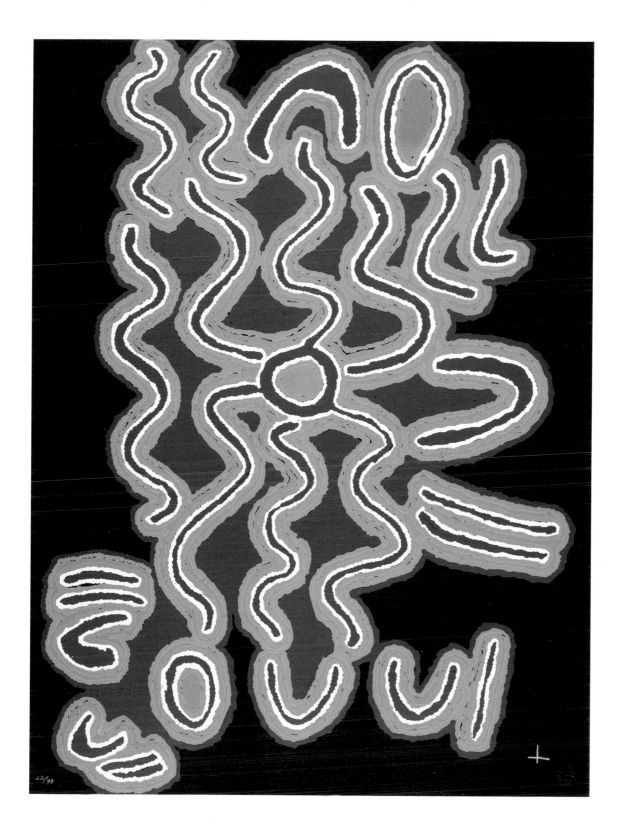

22/99

**Liwirrinki Dreaming
Lily Hargraves Nungarrayi**

medium
Etching: Sugar lift painting
and aquatint on two plates

edition size
99

collaborator/platemaker
Basil Hall

printer
Basil Hall assisted by
Natasha Rowell and Jo Diggens

studio
Basil Hall Editions, Darwin NT

plate created at
Lajamanu NT, July 2002

print published
Darwin NT, March 2003

paper
Magnia Pescia 300 gsm

paper size
760mm x 560mm

image size
490mm x 320mm

AAPN ID #
LH001

The Liwirrinki (burrowing skink; lerista species, squamata order) called Wamarru was a Japangardi from a place west of Yuendumu. Wamarru had fallen in love with Yulajina, a Nungarrayi. She was from the wrong skin group. She had been singing him. So Japangardi, he had been travelling to the place where the Nungarrayi lived.

Wamarru turned into a man and made some bush string and then a love belt. He put on his belt and sang that Nungarrayi, Yulajina. He made love to that Nungarrayi woman and took her back to his country. Two men made a big bush fire for the two (lover-boy and lover-girl) who ran away together. The print shows women, (U) shapes, sitting in a group performing the ceremony for this story with a ceremonial digging stick in the centre. The male and female skink ancestors are also depicted. It should be added that all male reptiles of the squamata order, including burrowing skinks, have two penises and that this particular skink already had a 'wife' at the time he had this sexual encounter with his new 'girlfriend'.

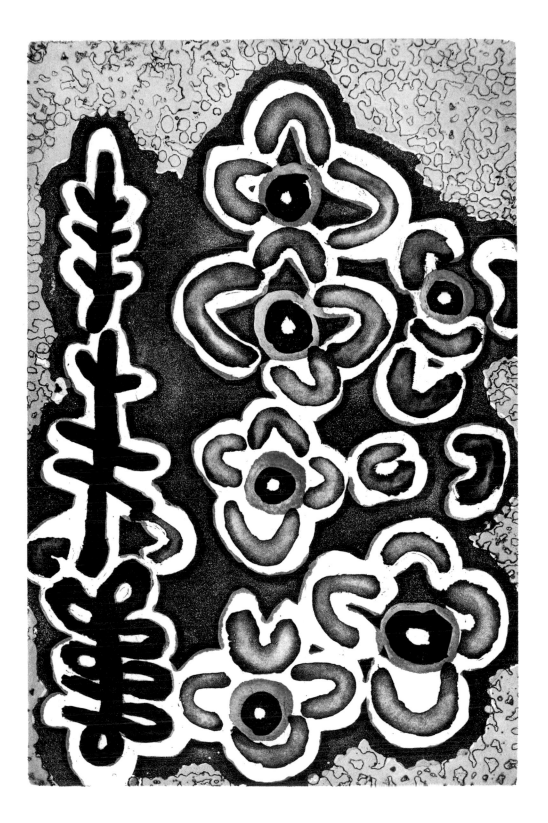

Yumurrpa – Big Bush Potato Dreaming
Liddy Nelson Nakamarra

this print and Liddy's other Bush Potato etching titled 'Wapurtarli' together depict the epic battle between the big bush potato and the little bush potato. It is a metaphor for how different groups of Warlpiri people learnt to live in harmony with one another. The big and little bush potato existed as people during the creation time but also represent plants which are an important food source, each of which competes for space in the harsh desert environment. The Jupurrurla and Jakamarra men (fathers and sons) fight with an army of men of the same skin groups. While the full story is a narrative battle that took place during the creation period referred to as the Dreaming, it is also a major ceremony, which is re-enacted to this day in Warlpiri culture. This Dreaming took place at Yumurrpa close to Yuendumu.

medium
Etching: Sugar lift painting and aquatint on two plates

edition size
99

collaborator/platemaker
Basil Hall

printer
Basil Hall assisted by Natasha Rowell and Jo Diggens

studio
Basil Hall Editions, Darwin NT

plate created at
Lajamanu NT, July 2002

print published
Darwin NT, March 2003

paper
Magnia Pescia 300 gsm

paper size
760mm x 560mm

image size
490mm x 320mm

AAPN ID #
LH001

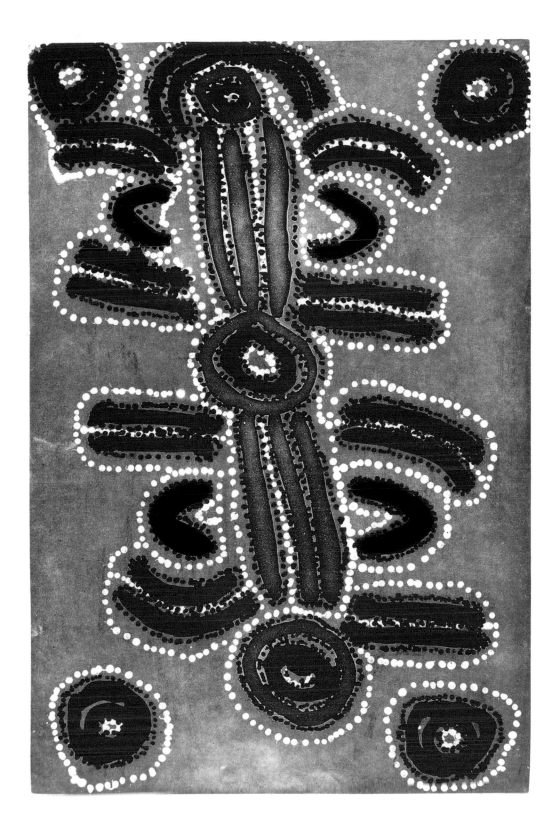

Wapurtarli – Little Bush Potato
Liddy Nelson Nakamarra

medium
Etching: sugar lift painting,
 aquatint and a la poupee
inking on one plate

edition size
99

collaborator/platemaker
Basil Hall

printer
Natasha Rowell

studio
Basil Hall Editions, Darwin NT

plate created
Lajamanu NT, July 2002

print published
Darwin NT, February 2003

paper
Hahnemuhle 350gsm

paper size
760mm x 560mm

image size
490mm x 330mm

AAPN ID #
LN008

This is an important Jukurrpa (Dreaming) performed ritually in ceremony by men and women of the Nakamarra, Jakamarra, Jupurrurla and Napurrurla skin groups. The song is closely associated with Yilpinji songs amongst these skin groups. The bush potato is a major food source and a very important Dreaming for the Warlpiri people. This print and Liddy's other Bush Potato etching titled 'Yumurrpa' tell the story of an important site in Warlpiri country. The story tells of a big fight amongst Warlpiri people that occurred during the Jukurrpa (Dreaming) and how eventually harmony was restored by two warring brothers laying down their weapons and making peace. It is a morality tale that dictates Warlpiri behaviour and obligations toward one another and other Warlpiri people. This harmony is exemplified by the fact that both species of yam grow on the same site. These are Wapurtarli (the little potato) and Yarla (the big potato). Women (U shapes) are shown digging for yam with their coolamon dishes and digging sticks. They bring little bush potatoes to the others. The bush potato plant is shown with its tubers extending outwards.

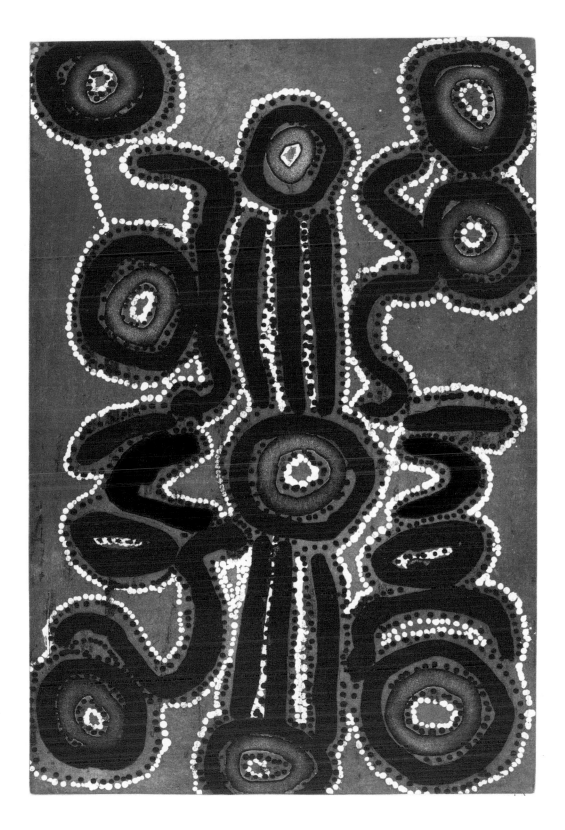

*t*his image and its companion Punyarnita II (see page 47) depicts some of Lucy's country far to the south of Balgo, in the Great Sandy Desert. This country is known as Punyarnita and is named for the soakwater, or *tjuyulyu*, featured in the centre of the painting. *Tali*, or sand dunes, dominate the landscape of the area, while *pura* (bush tomato), *tjunta* (bush onion) and *karnti* (bush potato) are commonly found here. The small dots depict the variety of these foods. The U shapes represent women performing ceremony to ensure the bush foods will remain abundant and maintain their strong connections with country.

medium
Original Screenprint

edition size
99

printer
Theo Tremblay assisted
by Barak Zelig

studio
Editions Tremblay NFP,
Bungendore NSW

accetates created
Warlayirti Artists,
Balgo Hills WA June 2002

print published
Editions Trembley NFP,
Bungendore NSW

paper
Magnani Pescia, 300gsm white

paper size
760mm x 560mm

image size
750mm x 550mm

AAPN ID #
LY001

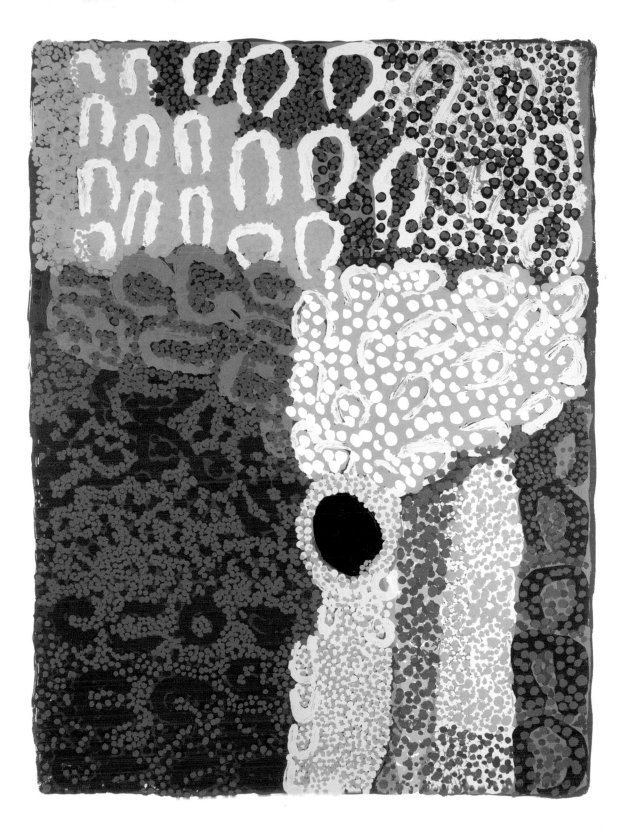

*a*mongst the Warlpiri, women and men share many rituals, customs, Dreamings and practices involved in *Yilpinji*, Love Magic. This print shows women (U shapes) making *Majardi*, Love Magic Hair Belts. Having fallen in love the girl goes to her female relatives and is instructed on how to attract her man as a lover. She weaves a belt while singing *Yilpinji* songs imbuing the belt with magic. When the man approaches she entices him with her charms until he comes under the influence of her allure. She reveals the belt as his ardour grows and persuades him to place the belt around her waist. As he does he falls under her spell and they go off together in to the long grass to make love. Once their love is consummated they walk off into the bush together as a couple. Together they eat bush plums and hunt for food. Other important Warlpiri, on learning of their tryst, follow them and confront them as a couple and also eat the bush plums. In this way the group recognises their relationship and acknowledges that it is an appropriate match. They are now recognised by all as a couple.

medium
Original Screenprint

edition size
99

printer
Theo Tremblay assisted by
Barak Zelig

studio
Editions Tremblay NFP,
Bungendore NSW

lino created at
Warlayirti Artists,
Balgo Hills WA June 2002

print published
Bungendore NSW, May 2003

paper
Maganani Pescia, 300gsm white

size
760mm x 560mm

image
740mm 540mm

AAPN ID #
LY002

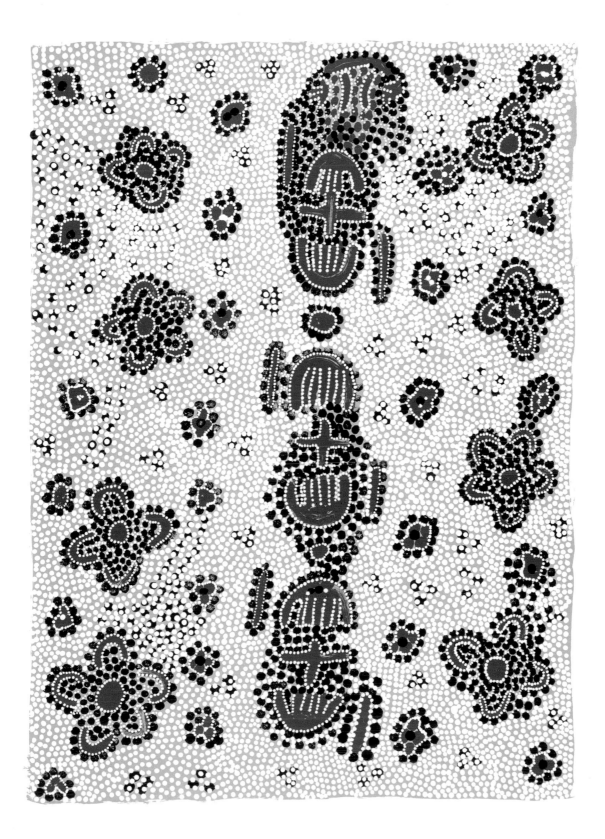

Yanjirlpiri
Paddy Sims Japaljarri

Yaripirlangu, meaning 'star' in Warlpiri is the place for this Dreaming. There is a collection of rock clusters there, which are stars that came down to earth to rest on the ground (meteorites). It is an important place for initiation ceremonies and part of this *Jukurrpa* or Dreaming is closely associated with secret sacred business.

Seven Dreaming Napaljarri women (known in astronomy as the Pleiades) are being pursued by a Jakamarra man (the Morning Star in Orion's belt). The women travelled from Purrpala to Yaripirlangu and onto Kurlangalimpa near Yanjirlpiri. Here in a final attempt to escape the Jakamarra they become fire and ascend to the heavens to become stars. They can be seen in the night sky today, forever just out of reach of the Jakamarra. This Dreaming belongs to Japaljarri and Jungarrayi men and Napaljarri and Nungarrayi women and much of it cannot be disclosed to the uninitiated. This is another version (a Warlpiri one) related to the Nakarra Nakarra of the Seven Sisters Dreaming of the Kukatja people.

medium
Two plate colour etching
with sugarlift aquatint, aquatint
and burnishing

edition size
99

collaborator/platemaker
Basil Hall

printers
Basil Hall and Natasha Rowell

studio
Basil Hall Editions, Darwin NT

plates created
Warlukurlangu Artists,
Yuendumu NT, July 2002

print published
Darwin NT, May 2003

paper
Hahnemuhle 350gsm

paper size
560 mm x 760 mm

image size
325mm x 490mm

AAPN ID #
PS002

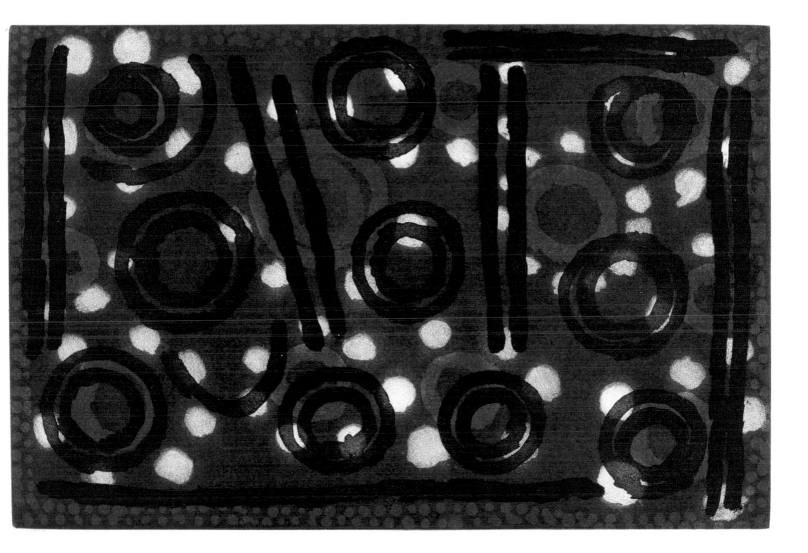

Yilpinji should be understood as part of Indigenous Australian religion, The Dreaming. 'The Dreaming', like "Love Magic", is an English translation that borders on the derisory. In the Warlpiri language, the word for this central, all-embracing concept is 'Jukurrpa' and in the Kukatja language, 'Tjukurrpa'. It refers to the time of the Ancestral Heroes, and the institution of the Law, and is the central core of Indigenous religious belief. People 'own' or 'manage' Dreamings, either as an inheritance from their fathers and grandfathers, or from their mothers' side. ● Indigenous Australian religion – known in English translation as either 'Dreamtime', or 'Dreaming' – lies at the heart of traditionally oriented Indigenous artistic production. It is unlike Christianity or Judaism, which may be glossed as "abstract" religions, where the spiritual is usually distinguished from the secular or the profane. By contrast, Indigenous religion is pre-eminently practical, being literally grounded in the land itself. For traditionally orientated Aboriginal Australians, the sacred and the profane are not distinct, separate spheres, as is the case with many of the world's religions. 'Dreamings' and 'Dreaming narratives' always relate to specific tracts of land.

● So, all Dreamings and Dreaming narratives are site-specific. Most importantly, for traditionally oriented Indigenous Australian people, religious belief is in fact inseparable from the land itself, regardless of the language group to which an individual or family belongs. ● 'Dreamings' and their accompanying narratives often recount the heroic journeying or exploits of Dreaming Ancestors, who created all natural phenomena. The behaviour of the Dreaming Ancestors is always exemplary; regardless of whether the way they act is 'good' or 'bad'. Not matter whether Dreaming Ancestors behave well, or inappropriately, they act as exemplars insofar as people can always learn from their exploits.

● Equally, because Dreamings and Dreaming narratives are literally planted in the ground, and relate to specific geographical areas, there is a great deal to be learned about the environment generally, including local flora and fauna, natural landmarks, for example rocks and small hills, and the vitally important matter of the availability of permanent water. Artworks and the Dreaming narratives that accompany them have a didactic dimension, providing detailed information about local environments and eco-systems. ● As prominent Aboriginal artist and teacher Jeannie Herbert Nungarrayi describes it: The Dreaming is an all-embracing concept that provides rules for living, a moral code, as well as rules for interacting with the natural environment. The philosophy behind it is holistic – the Jukurrpa provides for a total, integrated way of life. It is important to understand that for Aboriginal people living in remote Aboriginal settlements the Dreaming is not something that has been consigned to the past but is a lived daily reality. (Jeannie Herbert Nungarrayi, Personal Communication to Christine Nicholls, Lajamanu, June 1994).

Because there are 250 separate Aboriginal languages in Australia, there are also many different words for the concept of 'The Dreaming'. Examples of these include Altyerr (Eastern Anmatyerr) and Ngarankarni (Ngarinyin). ● In fact the word 'Dreaming' is a simplistic and rough English translation of this holistic and complex concept, in spite of its being the preferred term to describe Indigenous religion at present. The way that such English 'translations' are bandied around tends to erase the complexities of the concept of the 'Dreaming', by emphasizing its putatively magical, fantastic and illusory attributes, when Dreaming is understood to be reality by Aboriginal adherents – grounded in the earth itself. Dreaming provides a total framework that accounts for every aspect of existence. ● It could be argued that the prevalent understanding of the words 'Dreaming' and 'Dreamtime' in non-Aboriginal Australia ultimately deprives 'Dreaming' of the status and dignity accorded to other forms of religious belief. ● Dreaming is considered to be ever present, evident on and in people's bodies, in their ceremonies, on and in the land, and in landforms, and in the markings used in the creation of visual art, whether body painting, painting on other natural surfaces such as rocks or cliff-faces, or on canvas or other media. ● All aspects of existence are infused and marked with Dreaming. People, animals, life forms, landforms and other natural phenomena are all manifestations of Dreaming activity, and have the capacity to move from one state to another – for example, from person to animal or plant ancestor and morphing back again into person. Shape-changing and state–shifting characterize Dreamings and Dreaming Ancestors. 'Dreaming' also dictates what subject matter that Aboriginal artists are permitted to paint under their Law, as well as what subject matter is prohibited. ● Dreaming informs the past, present and future, and dictates all moral and ethical behaviour as well as people's relationships with the natural environment. While this concept varies to some degree among the many Aboriginal groups in Australia, it is central to Australian Aboriginal religious belief. ● In pre-contact times singing, dancing, painting, were not separate activities, but enacted as part of the total ceremonial context. Dreamings can be sung, told as lengthy oral narratives, danced or painted. The familiar 'dot and circle' paintings from Central Australia and the Western Desert and 'rarrk' paintings from Arnhem Land are all based on Dreaming narratives that relate to specific physical and cultural landscapes. ● Dreamings are Ancestral Beings associated with life-forces and creative powers, knowledge of which is on occasion communicated to people by means of dreams. Invisible beings (with a variety of different names in different languages) carry around knowledge of these beings and associated rituals, designs, songs, places, ceremonies that they also on occasion communicate to people through their dreams while asleep. The 'Dreaming' and the actions and behaviour of the Ancestral Beings who are in fact themselves 'Dreamings' provides the model or the template for all human and non-human activity, social behaviour, natural development, ethics and morals.

● 'Dreaming' is not conceived as being located in an historical past (as is, say the case of the Biblical Genesis) but as an eternal process that involves the maintenance of these life-forces, symbolized as people, spirits, and as other natural species. A 'Dreaming' may be an animal for example a kangaroo or an emu, or an insect, for example a mosquito or a honey ant, or a human Ancestor, a type of flora (e.g. a bush medicine vine, or a bush bean tree) or another kind of 'Bush Tucker' (eg. yam, bush berries, bush tomato, bush onion) or any other part of the natural world or environment – water, or specific waterholes, stars or constellations (eg The Seven Sisters, The Milky Way). The Dreaming may be a shape-changer and manifest itself in various different ways or forms. People paint their own Dreamings – under Indigenous Law, they may not paint that of another person or group with the rights to that Dreaming. ● Dreaming narratives operate at many levels. At one level they are Creation stories, the significance of which is on a par with that of Genesis in the Christian Bible. Each Dreaming has an accompanying narrative, which may be thousands of words in length. Narratives based on Yilpinji are themselves Dreaming narratives. ● Paintings of *Yilpinji* not only relate to moral and ethical behaviour and the transgressions that sometimes occur but, like other Dreaming narratives, they are attached to specific tracts of land. The often-lengthy narratives associated with the *Yilpinji* paintings provide guidance about how (ideally) people should interrelate with one's fellow human beings as well as providing templates for their interactions with other species and with the natural world. Dreaming narratives relating to Love Magic ceremonies and themes have a range of manifestations, and like other Indigenous arts, may be expressed through a variety of art forms. Dreaming narratives are deemed to be 'owned' by certain individuals and or groups of Indigenous Australian people. Usually only certain parts of Dreaming narratives are made publicly available to outsiders or children. The paintings act as mnemonic devices for the longer narratives associated with them. Dreaming narratives also relate closely to specific tracts of land and environmental features. At the same time they deal with the "big" or important issues and subjects that concern all human beings. ● Many of these Dreaming narratives and their accompanying visual manifestations have a *Yilpinji* ('love magic') manifestation or component, providing advice on how *not* to act in affairs of the heart, and by implication, indicating what constitutes desirable behaviour in this realm. In other words, *Yilpinji* operate in the realm of morality – it is most certainly not a matter of 'anything goes' in the sphere of love and romance.

Oppostie page; Punuyarnita II, by Lucy Yukenbarri Napanangka

the site of this Jukurrpa (Dreaming) is Ngarlu, a pirli (rock hill) south east of Yuendumu. It is where a Jungarrayi man fell in love with a Napangardi woman (his mother-in-law), a taboo relationship under the Warlpiri skin group system. Japaljarri and Jampijinpa men were travelling east to Kurlpurlurnu. A Jungarrayi man called Linjipirlingirnti watched a woman from where he sat whilst she was urinating. He was so impressed with what he saw that he decided to woo her. His imprint has been left in the rocks which reminds the people of his thinking. Whilst he was sitting at Yumurrurluwarnu he spun some *wirriji* (hair string) and sung a love song. He also sent a bird to the Napangardi woman with the magic to entice her. When the two met at Ngarlu they made love and as a result of the taboo relationship were turned to stone. They are seen *in flagrante delicto* in two conjoined rocks at Ngarlu. A broken boulder close to a long water hole reminds people of this union.

Kalalpalu yanu jarrarda-parnta kakarrumpayi.
He grabbed her and took her to make love with her.

medium
Etching: Sugar lift painting, deep bite, aquatint and relif roll on two plates

edition size
99

collaborator/platemaker
Basil Hall

printer
Matthew Ablitt

studio
Basil Hall Editions, Darwin NT

plates created
Warlukurlangu Artists, Yuendumu NT, May 2002

print published
Darwin NT, April 2003

paper
Hahnemhule 350gsm

paper size
760mm x 560mm

image size
490mm x 325mm

AAPN ID #
PS003

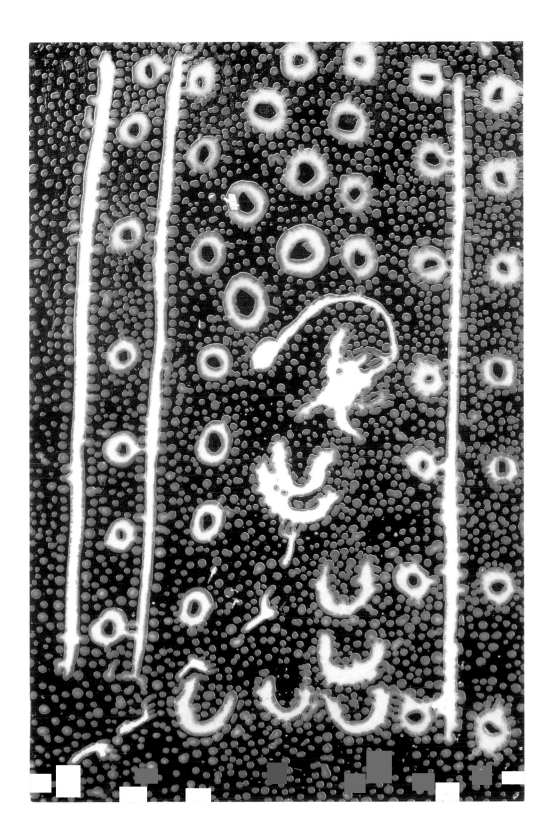

medium
Two colour etching.
Sugar lift painting, deep bite,
aquatint and relief roll on
two plates

edition size
99

collaborator/platemaker
Basil Hall

printer
Matthew Ablitt

studio
Basil Hall Editions, Darwin NT

plates created
Warlukurlangu Artists,
Yuendumu NT, May 2002

print published
Darwin, June 2003

paper
Hahnemuhle 350gsm

paper size
760 mm x 560 mm

image size
490mm x 325 mm

AAPN ID #
PS004

the site of this Jukurrpa (Dreaming) is Ngarlu, a pirli (rock hill) south east of Yuendumu. As with the previous picture, it is where a Jungarrayi man fell in love with a Napangardi woman (his mother-in-law), a taboo relationship under the Warlpiri skin group system. Japaljarri and Jampijinpa men were travelling east to Kurpurlurnu. A Jungarrayi man called Linjipirlingirnti watched a woman from where he sat whilst she was urinating. He was so impressed with what he saw that he decided to woo her. His imprint has been left in the rocks which reminds the people of his thinking. Whilst he was sitting at Yumurrurluwarnu he spun some Wirriji (hair string) and sang a love song. He also sent a bird to the Napangardi woman with the magic to entice her. When the two met at Ngarlu they made love and as a result of the taboo relationship were turned to stone. They are seen *in flagrante delicto* in two conjoined rocks at Ngarlu. A broken boulder close two a long water hole (representing a pool or urine) reminds the people of this union.

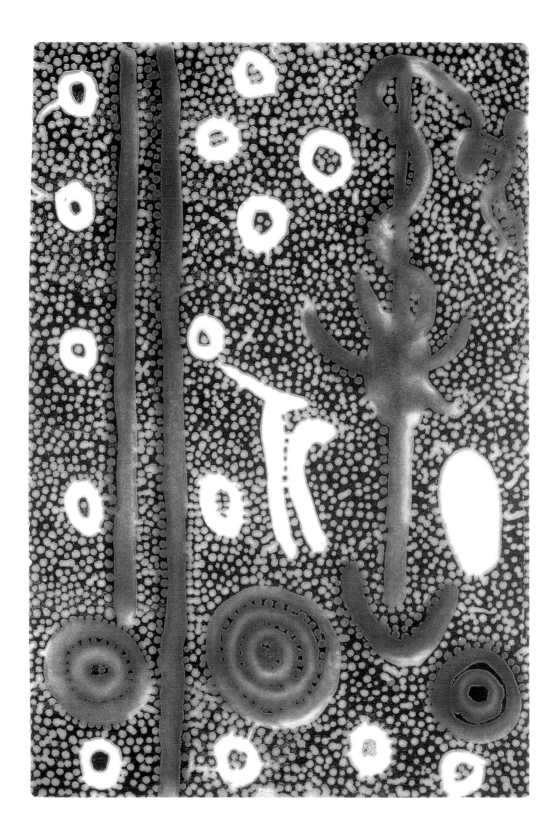

Rosie Tasman Napurrurla
Grass Seed Dreaming – Bush Grain – Ngurlu

*t*his story is for the Napurrurla and Nakamarra women (aunts and nieces) and Jupurrurla and Jakamarra men (fathers and sons) skin groups. The print shows ant nests interconnected with the tracks of the ants as they collect grass to turn into milk for their baby ants. Kurlukuku, the Diamond Dove*, also gathers grass seeds that have fallen to the ground while the women gather seeds from the long stems and use them to make damper. This Dreaming takes place near the Granites in the Tanami Desert at a place called Miya Miya.

* bronzewing pigeon or dove, *Geopelia cuneata*.

'Nyanjarlajiyijiyi', ngulaji yangka kujaka nyinami wati jalangu ngurrju-nyayirni kurduwarnu yuntardi-nyayirni, kujakalurla waninja-jarri panu-nyayirni karnta – wati nyanjarlajiyijiyikiji. Nyanjarlajiyijiyi is a grown man who is very nice and very handsome. One who all the women fall in love with – a good-looking man.

medium
Screenprint: Opaque paint on six acetates

edition size
94

collaborator/platemaker
Basil Hall

printer
Basil Hall

studio
Basil Hall Editions, Darwin NT

acetates created
Lajamanu, NT July 2002

print published
Darwin NT, November 2002

paper
Magnani Pescia 300gsm

paper size
760mm x 560mm

image size
705mm x 495mm

AAPN ID #
RT013

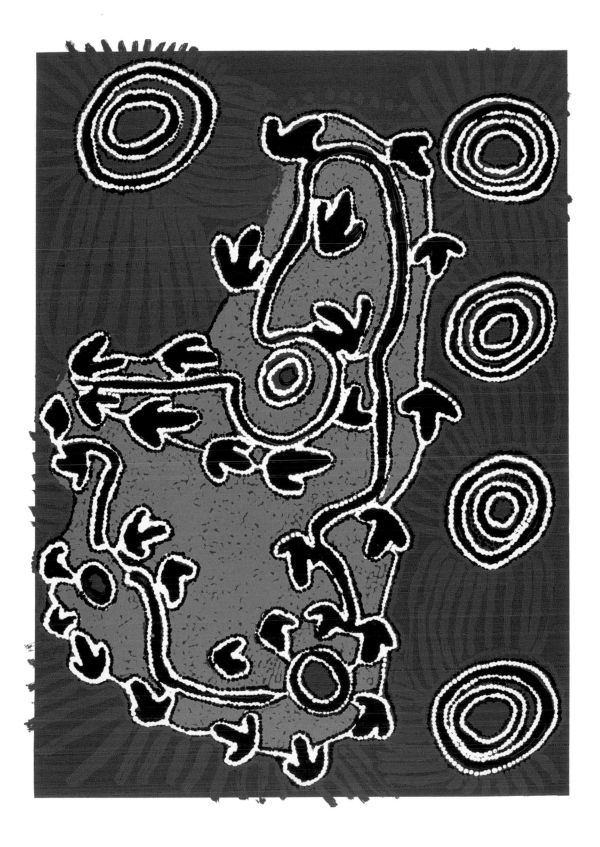

Rosie Tasman Napurrurla

Grass Seed Dreaming – Bush Grain – Ngurlu

*t*his story is for the Napurrurla and Nakamarra women (aunts and nieces) and Jupurrurla and Jakamarra men (fathers and sons) skin groups. The print tells the Jukurrpa or Dreaming story about the women following the tracks of the Diamond Dove, Kurlukuku, in order to find and gather grass seeds. The dove gathers the seeds that have fallen to the ground while the women gather seeds from the long stems and use them to make damper. The seeds were collected in coolamons and taken home to be sorted ready for grinding. The ground seeds are then ready to be made in to damper. The elongated oval shapes in the centre of the print represent coolamons in which the women are collecting the stems and grains. They also represent the damper the women are cooking. Along the outside Rosie has depicted trees and clap sticks that are partially obscured by the design. These music sticks are used when Rosie sings and dances this particular Dreaming during ceremony. The song is sung by both the men and the women. This Dreaming takes place near the Granites in the Tanami desert at a place called Miya Miya.

medium
Line etching. Several drypoint prints of this image were made prior to the plate being etched

edition size
99

collaborator/platemaker
Basil Hall

printer
Natasha Rowell

studio
Basil Hall Editions, Darwin NT

plates created
Lajamanu, July 2002

print published
Darwin NT, November 2002

paper
Hahnemhule 350gsm

paper size
560mm x 760mm

image size
330 mm x 495mm

AAPN ID #
RT014

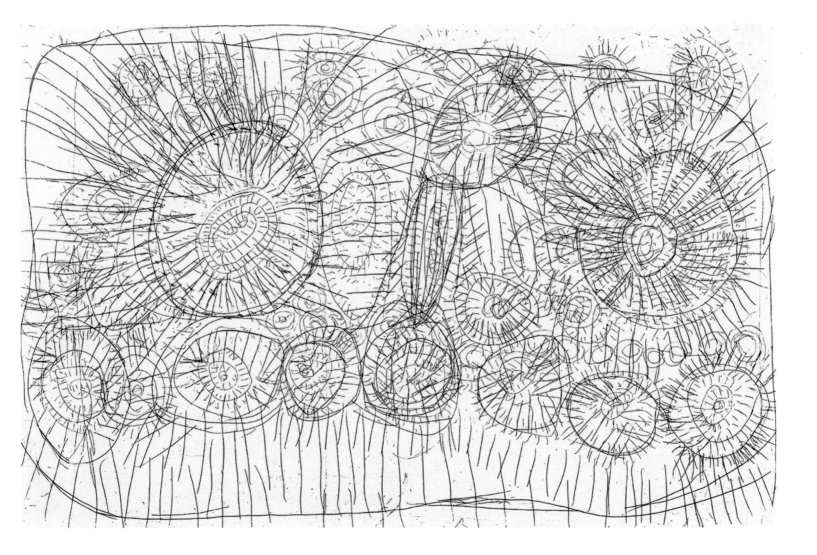

d uring the Tjukurrpa (Dreaming) a man and woman were travelling around this area which is located, at the top of the Canning Stock Route. They stopped in the country known as Kaningarra to dig a hole for water, where a permanent spring now exists. The two people are shown as U shapes. They are shown camping by the spring. Surrounding them is the abundance of *tjunta*, or bush onion, which can be found in this region today. The arc shapes along the edges are *tali*, or sand-hills, which dominate the landscape of the area. The iridescent colours reflect the sky, the white and black stones and the colours of the sand hills as the late afternoon advances toward sundown.

medium
Original screenprint

edition size
99

printer
Theo Tremblay, Bruce
and Betty Clarke

studio
Editions Tremblay NFP,
Bungendore NSW in association
with Select Screen Prints,
Queanbeyan NSW

acetates created
Warlayirti Artists,
Balgo Hills WA, June 2002

print published
Bungendore NSW, June 2003

paper
Magnani Pescia, 300gsm white

paper size
760mm x 560mm

image size
760mm x 560mm

AAPN ID #
SB020

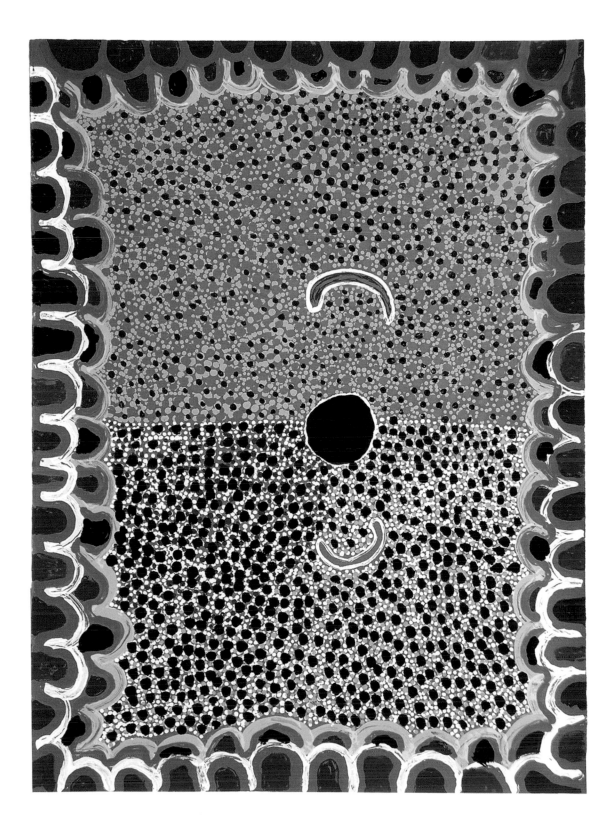

n

garlu is country belonging to the Anmatyerr language group south-east of Yuendumu. The Jukurrpa of this place tells of a Jungarrayi man, named Linjipirlingirnti, who is travelling west to another country for Kurdiji, men's ceremonial business. As the Jungarrayi man travelled he saw a Napangardi woman, his mother-in-law according to the Warlpiri kin system and therefore forbidden to him as a wife or sexual partner. Linjipirlingirnti watched the woman from where he sat whilst she was urinating. He was so impressed with what he saw that he decided to woo her. His imprint has been left in the rocks, which reminds the people of his thinking. He had weapons and a parraja (coolamon or wooden water carrier). Linjipirlingirnti fell in love with this woman. When he arrived back home to Ngarlu he couldn1t stop thinking about her. A *Jurlpu* (bird) carried his love songs over to the Napangardi. The *Jurlpu* (bird) flew back with the Napangardi on his wings, to join with the Jungarrayi at Ngarlu. The people of Ngarlu gossiped about this wrong-skin love union.

(Continued on page 85).

medium
Etching. Sugar lift painting and aquatint on two plates

edition size
99

collaborator/platemaker
Basil Hall

printer
Basil Hall and Natasha Rowell

studio
Basil Hall Editions, Darwin NT

plates created
Warlukurlangu Artists, Yuendumu NT, May 2002

print published
January 2003

paper
Hahnemuhle 350gsm

paper size
560mm x 760mm

image size
325mm x 490mm

AAPN ID #
SM042

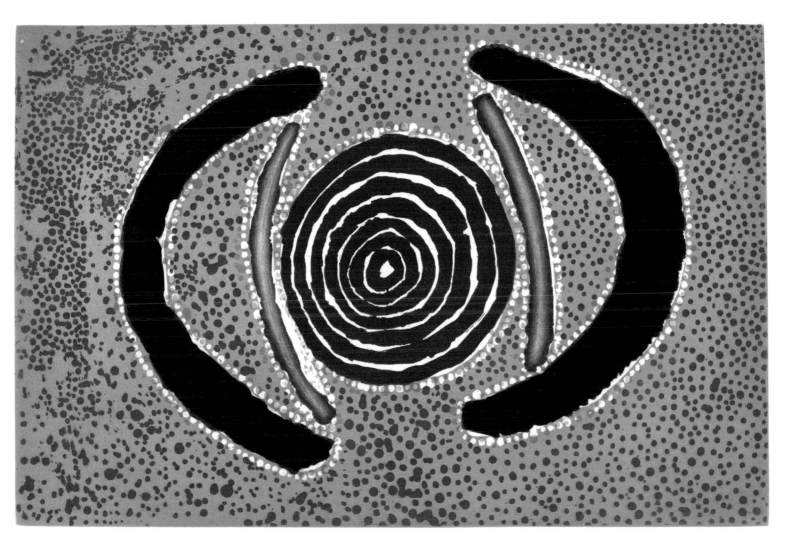

'this man here Yimarimari, a Jakamarra from Yarwalga, did not want to marry his promised girl. He was in love with two sisters from the wrong skin group. They were Nangalas (He not only wanted one classificatory mother in law – he wanted two!) The older one already had two children. When the time came for the Big Business he started to sing this song as he walked away from his people. Jakamarra was singing all the way carrying his shield looking for the two Nangala women with whom he wanted to make love, even though it was wrong way. No worries. He gathered some bark and made some bush string rubbing the bark on his thigh as he sang. From the string he made a love belt, a *majardi*. He put on the dance belt and sang and danced to charm the two women. He found some tracks of the two Nangalas and followed them walking on their tracks. He was cracking rude, sexy jokes and kept singing and dancing all the way. He saw where they had been making wee wee and where they had been sitting. He kept tracking them a long way. He crossed Kurungku, the land of the Kurlukuku, the little dove with the red eye. He saw the big wild dove in Walamurrulu, further to the west. He sings their songs, the songs of their country. He walked all the way up to Duck Pond, or Kulangalimpa. There the two Nangala women heard them singing. They said: 'He must love us'. He made love to both of them and took them back to his country.

medium
Etching. Sugar lift painting and aquatint on two plates

edition size
99

collaborator/platemaker
Basil Hall

printer
Natasha Rowell and Matthew Ablitt

studio
Basil Hall Editions, Darwin NT

accetates created at
Lajamanu

print published
Darwin NT, May 2003

paper
Hahnemuhle 350gsm

paper size
760mm x 560mm

image size
490mm x 230mm

AAPN ID #
TM001

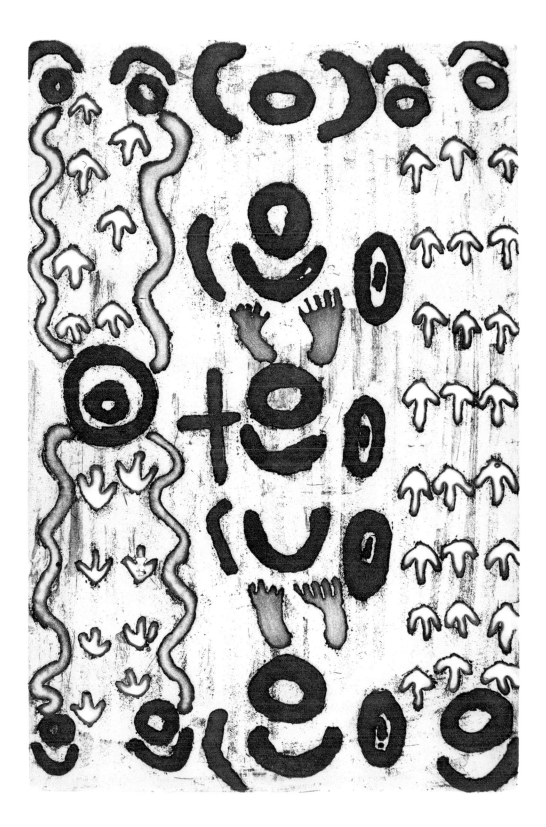

this story is about married men and women travelling. They travel all the way from Yuendumu in the South, along Mission Creek, which is an important Dreaming site. Wampana starts travelling from Wirnparrku on the way to Ngama. Wampana has been travelling carrying a big Warna, snake. That snake is called Yarranji. They cut him and carry him all the way. All the way they dance together, men and women. They tie up bushes and make Witi poles. They tie the bushes together with *Ngalyipi**, bush string and make the poles for ceremony. The Wampana men and women dance around the poles all the way along their travels as far as Darwin.

* Snake vine, *Timospora Smilacina* which can be used as a rope and also as a medicine somewhat similar to aloe vera.

medium
Screenprint

edition size
99

platemaker/collaborator
Basil Hall

printer
Simon White

studio
Basil Hall Editions,
Darwin NT

acetates created
Lajamanu NT, July 2002

print published
Darwin NT, May 2003

paper
Magnani Pescia 300 gsm

paper size
760mm x 560mm

image size
690mm x 400mm

AAPN ID #
TM002

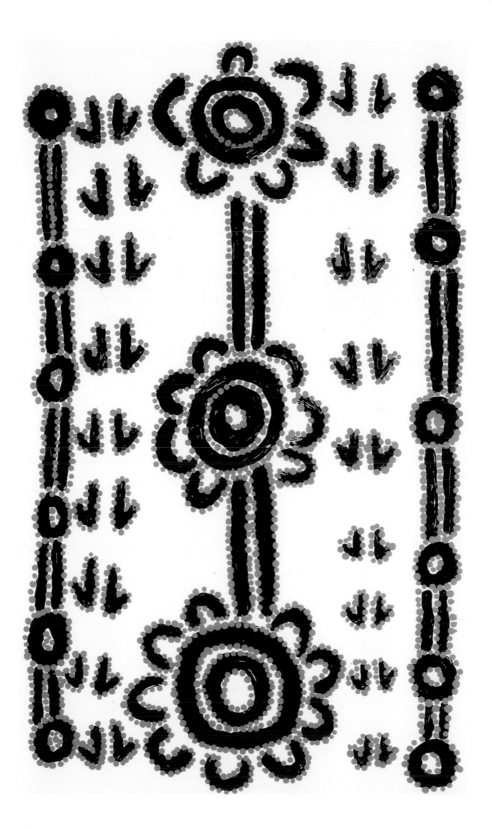

Wati Kutjarra
Tjama (Freda) Napanangka

medium
Linocut

edition size
99

printer
Theo Tremblay assisted
by Barak Zrlig

studio
Editions Tremblay NFP,
Bungendore NSW

block created
Warlayirti Artists,
Balgo Hills WA June 2002

print published
Bungendore NSW,
November 2002

paper
Magnani Pescia, 300gsm white

paper size
760mm x 560mm

image size
600mm x 500mm

AAPN ID #
TN004

t he artist has depicted part of the story for the Wati Kutjarra Tjukurrpa or Two Men Dreaming, in the country south of Balgo. The central shapes are the two brothers (the larger, single shape is the older brother, and the smaller inside shape, is the younger one) sleeping by their fire in country called Yayarr. The Wati Kutjarra Tjukurrpa is an immensely significant story for a number of Indigenous Australian groups. In their ancestral journeyings, these Two Goanna Men traversed a very large expanse of land including that of the Warlpiri, Pintupi, Kukatja, Walmajarri and Ngardi peoples, as well as even further afield, through the Pitjantjatjara lands. The story arose as a result of the lawlessness of a lustful old man of the Tjungurrayi skin group who lived with many women with whom he had sexual relations, regardless of whether or not they were in the 'right' kinship affiliation. Whenever boy children were born to any of his wives, Tjungurrayi would order the babies to be killed. By ordering the deaths of the boys, Tjungurrayi was clearly getting rid of potential sexual competitors. Eventually two baby boys were born at around the same time, to two of Tjungurrayi's many wives. The two young mothers defied their husband, taking the two babies far away from where the group was camped, to a place obscured by a large sandhill, where first they breast-fed their infants and then later, clandestinely smuggled food for the children to eat.

(Continued on page 85).

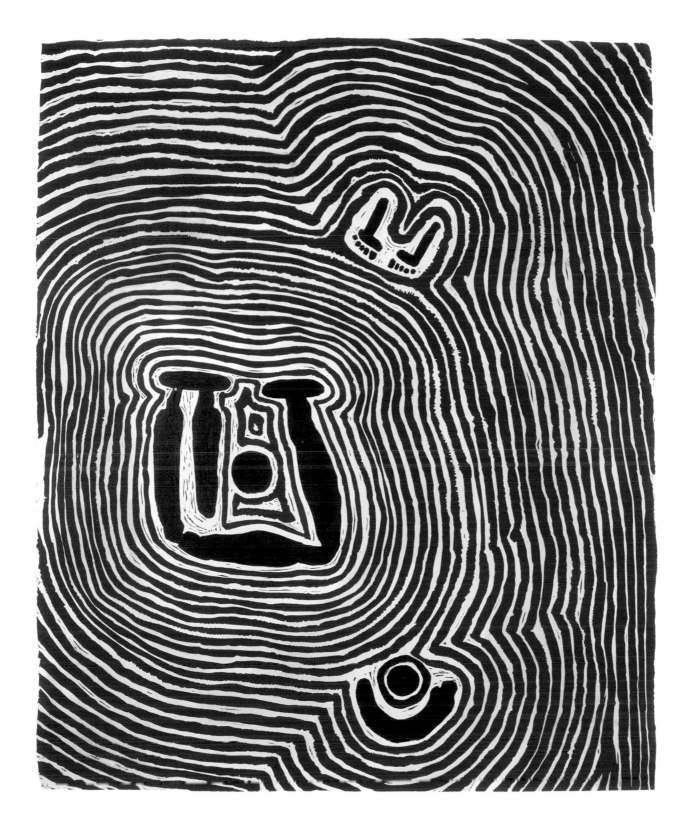

t jumpo Tjapanangka's print tells some of the story of the *Wati Kutjarra*, a prominent Dreaming in the Tanami and Great Sandy Deserts. The *Wati Kutjarra* were two ancestral brothers who travelled large areas of the Central and Western Deserts teaching ancestral people about food, fire and hunting. This print depicts the travels of the *Wati Kutjarra* to *Wilkinkarra* (Lake Mackay). The two oblong shapes represent the two brothers where they lay down to sleep and the impressions they left behind are seen in the country today. The central circle depicts the fire they lit that morphed into a rockhole. At either end of the painting, *wuungku* or *wilytja* (protected area or windbreak) made of spinifex are depicted. These protect the men during ceremony. This print represents an important men's ceremony, the details of which cannot be disclosed.

medium
Screenprint

edition size
99

printer
Barak Zelig

studio
Editions Tremblay NFP,
Bungendore NSW

accetates created at
Warlayirti Artists,
Balgo Hills WA, June 2002

print published
Editions Tremblay NFP,
Bungendore NSW July 2003

paper
Magnani Pescia 300gsm

paper size
1000mm x 700mm

image size
800mm x 540mm

AAPN ID #
TT007

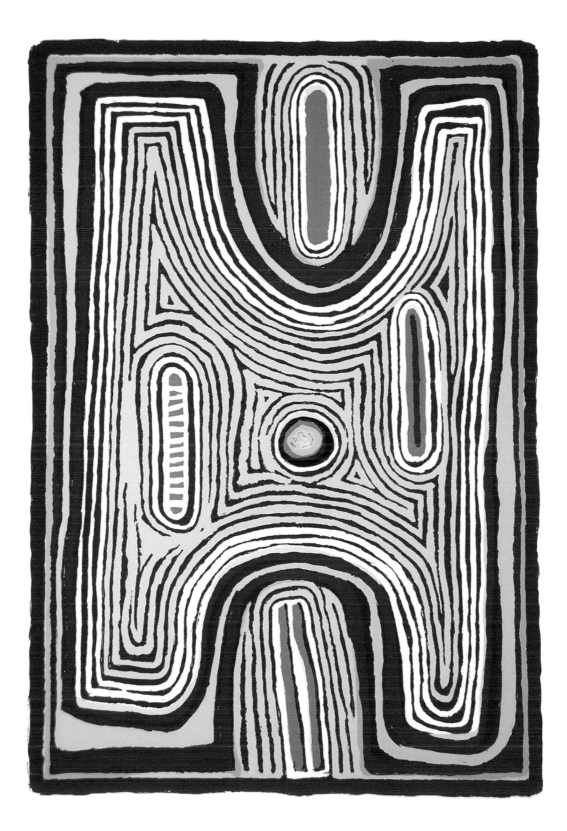

W

ayipi* is a plant creeper that grows along the ground, looking a little like a bush yam. Nampijinpa and Nangala women are shown as U shapes looking around for the *Wayipi*. They have with them *parraja* (coolamons or wooden food carrying dishes) and *karlangu* (digging sticks). The Jukurrpa (Dreaming) narrative for this print is about Jungarrayi, a Japangardi man, who travelled through country around Wanapiyi, a big hill just south west of Yuendumu. In this area he chased a number of Nangala and Nampijinpa women who were digging for *Wayipi* (Bush Carrot). The Japangardi man followed those women and tried to reach them in a cave where they were hiding. He managed to grab one of the women for his wife. Japangardi is shown in the painting, also as a U shape. He is depicted with his *karli* (rounded boomerangs) and *kurlarda* (spear).

*Boerhavia diffusa

medium
Etching. Sugar lift painting and aquatint with a la poupee inking on two plates

edition size
99

collaborator/printmaker
Basil Hall

printer
Natasha Rowell

studio
Basil Hall Editions, Darwin NT

plate created
Warlukurlangu Artists,
Yuendumu NT, May 2002

print published
Darwin NT, April 2003

paper
Hannemunule Cream

paper size
760mm x 560mm

image size
490mm x 325mm

AAPN ID #
UM001

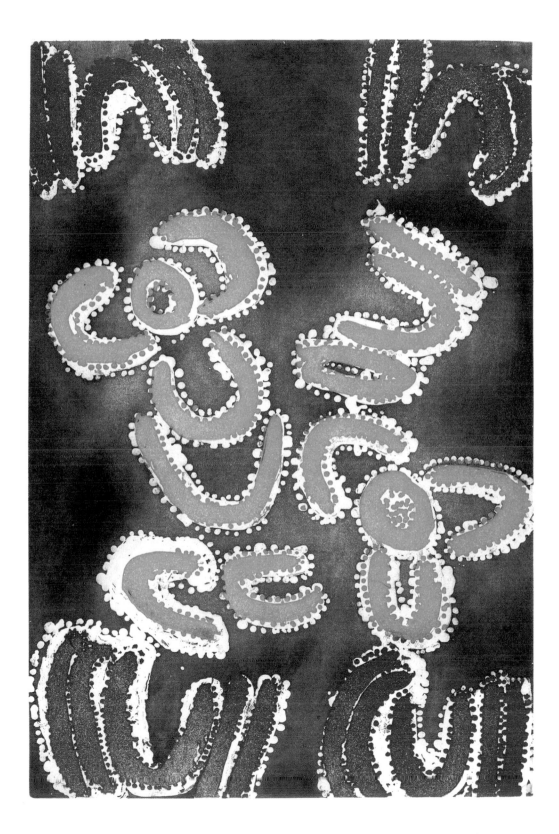

in 1999, an exhibition entitled *Love Magic: Erotics and Politics in Indigenous Art* was staged as part of Australian Perspecta 99, entitled *Living Here Now: Art and Politics.* As Mary Rivett has written, *...The exhibition brought together a selection of erotic works by Indigenous artists living in a wide variety of circumstances from both urban and remote communities around Australia. The exhibits employed several diverse mediums, including film, sewn fabric objects, carved wooden objects, bark, oil and acrylic paintings on canvas. Love Magic 'celebrates sexualities, gender, love and romance as well as the cultural politics of sexual expression' wrote the curators Gary Lee and Maurice O'Riordan.* (Rivett, 2005) ● Unfortunately, while in some ways this exhibition succeeded in terms of its courageous choice of hitherto unexamined subject matter, in other respects it reflected a profoundly eurocentric view of what constitutes erotica in Indigenous contexts. Therefore I must largely agree with Rivett's judgement regarding this exhibition: *...The central concept for the exhibition was a collection of male erotica created by Indigenous artists...The exhibition presented 'love magic' as erotic, salacious and imposed a European-Australian perspective onto yilpinji art, misunderstanding it in the process. Indigenous people perform love magic ceremonies discreetly, in separate small groups of men and women, and never in public.* ● This imperfect grasp on what constitutes 'love magic' in Indigenous circles has rather a lengthy history in both art and life, which continues into the present. An early example of this pertains to the depiction of a 'love magic' ritual in the Australian feature film Jedda. (1955) ● The film was released in the United States as Jedda the Uncivilised, which provides some insight into the stereotyped images of Aboriginality that were commonplace in the 1950s. ● The story line is of a tragically doomed liaison between a mixed race Aboriginal girl named *Jedda* (played by Rosalie Kunoth Monks), who seems to have been successfully assimilated into white society, and Marbuck (wonderfully performed by Robert Tudawali, a Top-Ender), a "tribal" dangerously sexy Aboriginal man replete with spears, boomerangs, head band and tribal bodily incisions. His shiny red loin cloth sexualizes him further by constantly drawing viewers' attention to the region of his crotch. ● *Jedda* is set on a pastoral property somewhere in northern Australia, and presents an idealized picture of station life and the relations existing between the Aboriginal employees who work on the station and their non-Aboriginal (in some cases part-Aboriginal) masters and mistresses.

The relationship between the colonizers and colonized is depicted as that of patient, caring parents and contented children. Throughout the film we see the smiling faces of the Aboriginal people as they go about their menial tasks, never complaining about their lot. ● At this time Australian Aboriginal people working on pastoral properties were for the most part paid in barely adequate food rations. There is no acknowledgement in the film of the fact that this is a colonial encounter, or of the historical conditions that pertained at that time. ● This film was made at the height of the era of the policy of assimilation for both Aboriginal people and immigrants. The fact that a lot of the station work for the Aboriginal workers was sheer drudgery, but also the documentary evidence that there was a good deal of resistance to this state of affairs, is completely glossed over. ● Despite this, the fictional station in *Jedda* is portrayed as a busy, thriving, and harmonious – until along comes the wild, untamed, oversexed Marbuck. ● It is assumed that Jedda will marry the 'good', that is assimilated, 'half-caste' Aboriginal man who is a stockman on the station. The actor playing this role in black-face was British with an Oxbridge accent, just to emphasize the level of civilization that Aborigines are able to attain so long as they have a bit of 'white' in them! Jedda's intended husband tells her that she is a 'nice piece of chocolate'. ● By contrast, Marbuck is a representation of archetypal 'untamed', wild, naked Indigeneity, replete with unchecked, animal sexual desires. ● So, when Marbuck sings a 'love magic' song to attract Jedda, she is rendered powerless. Unable to resist the song's 'black magic' Jedda is drawn towards Marbuck in an involuntary, dreamlike trance, or to put it into contemporary terms, like a disco chick on ecstasy! ● So Marbuck wins his sexual prize, and has his way with her. They run off together and eventually throw themselves over a steep cliff to their deaths. End of story. ● This film is imbued with the ideology of the inevitability of 'reversion' of Aboriginal people to their essentially 'primitive' state. This ideological position is a source of real tension in the film, because if such reversion is inevitable, what was the point of the assimilation policy, in the first place? ● Nowhere in the film is this ideology more apparent than in the scenes in which Tudawali performs a supposed 'love magic' ritual, which must be regarded as a gross travesty of 'the real thing', a form of epistemological violence. ● Presumably much of the responsibility for this burlesque performance needs to be sheeted home to Jedda's director, Charles Chauvel, who has Tudawali as Marbuck bring forth a huge, writhing snake as part of the 'love magic' ceremony he enacts. This is a Freudian phallic symbol par excellence, bearing no relationship to serious 'love magic' ceremonies.

● Marbuck also performs his ritual dance solo, alongside a musical accompanist playing the didgeridoo. Again, this is inaccurate, as love ceremonies are performed in groups (either all-male or all-female). ● Finally, when Jedda is quite literally moved by the music and song and, in her stupefied, zombie-like state begins to move towards Marbuck, showing that the 'love magic' has taken immediate effect, this too is but a parody of the reality. 'Love magic' rituals do not take immediate effect, like drinking some aphrodisiacal potion! ● When, in the early 1980s, I first watched these 'love magic' scenes from Jedda with a group of elderly Warlpiri women, they burst into uncontrollable gales of laughter regarding the silliness of it all, of this inane representation of what they call "Yilpinji". The Warlpiri expression "Ngalarriya, Ngalarriya, kuna-ku, kuna-ku" ('To laugh and laugh until the shit rolls out of you') provides a perfect summation of their response to this cinematic depiction of 'love magic'. ● Chauvel's caricature of a love magic ritual illustrates very well the maxim that a little knowledge can be a dangerous thing. ● More recently, Howard Morphy, in his survey of Indigenous Australian art (1998), has inaccurately glossed Centralian *yilpinji* as 'women's rituals'. While no doubt Morphy is confounding *yilpinji* with *yawulyu*, which are in fact 'women's rituals', he fails to recognize that men practice 'Yilpinji' to the same extent as women (if not more so). ● By contrast, T.G.H. Strehlow has written convincingly about 'love magic' in relation to the Central Australian Arrernte people, specifically men's ceremonies. The French anthropologist Barbara Glowczewski has written comprehensively about *Yilpinji* in relation to Warlpiri women's ceremonies, as has, to a lesser extent, her compatriot Françoise Dussart, and Australian anthropologists Isobel White and Diane Bell. Stephen Wild, an Australian musicologist, has recorded men's *Yilpinji* songs. Linguist Bob Dixon and poet Martin Duwell have published a book, *The Honey-Ant Men's Love Song* (1990) of Aboriginal men's love poetry, sung during ceremonies in various parts of Australia. ● But anthropological and other academic writing about the lifeways and knowledge systems of Indigenous people usually reaches only a minority audience. Such writing does not act as an antidote for more populist views such as the one purveyed by Charles Chauvel.

Opposite page; Jedda Film Poster. Image courtesy of ScreenSound Australia

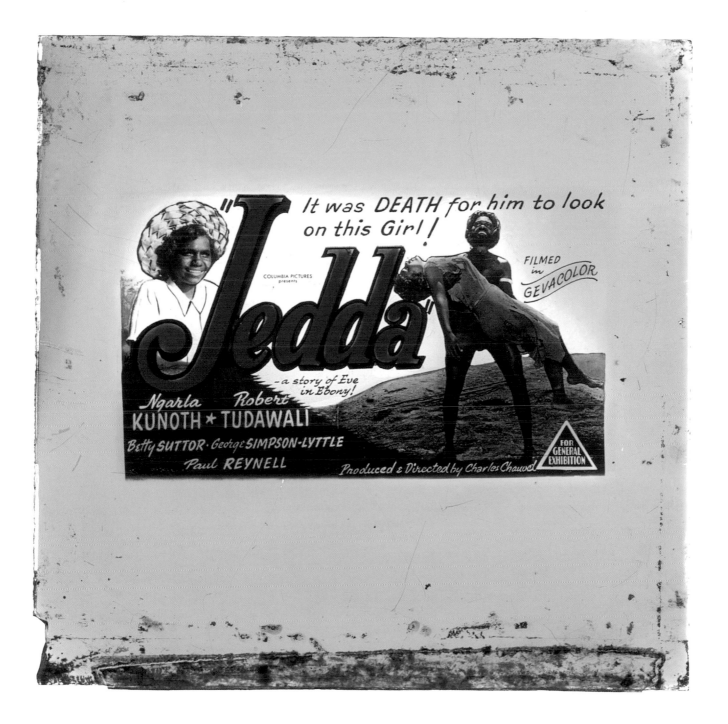

1

LOVE, WARLPIRI AND KUKATJA-STYLE, OR, THE 'LANGUAGE OF LOVE' IS NOT UNIVERSAL ● *...My face in thine eye, thine in mine appears, And true plaine hearts doe in the faces rest...* wrote the seventeenth century English poet John Donne, *in his The good tomorrow*, (Songs and Sonnets, c. 1633–1635) ● In Anglo-European love poetry, and literature generally, the *heart* is most often the figure of speech used to represent love. It is commonplace knowledge that a rich tradition of love songs, poetry, drama and other literature exists in the English language, as well as in European and Asian languages. In many Asian cultures, the theme of love tends to be expressed in less direct terms than is the case in Anglo-European literature ● Nevertheless numerous examples can be provided, including the celebrated Japanese epic *The Tale of Genji*, which is essentially a love story. ● The tradition of Indigenous Australian love poetry, song and other narratives, as well as the visual art tradition pertaining to love, is even longer. ● For the Warlpiri and the Kukatja peoples of Australia's Tanami and Western Desert regions, the primary seat of the emotions is not the heart, but the *stomach*. Happiness, sadness, rage, anger, desire, concern, anxiety, depression, feelings of protectiveness and responsibility towards others, indeed all the intuitive faculties are thought to be located in one's *miyalu*, or stomach. ● The Warlpiri and Kukatja conceptualisations contrast markedly the dominant Anglo-European cultural metaphors used to describe the experience of falling passionately in love. While English has expressions like 'broken-hearted', 'heart-breaking', 'heartless', 'heart-rending', 'heartache', 'open-hearted', or a 'heart-throb' used to describe a sexually attractive person, there exists an equally rich vocabulary in the Warlpiri language and the Kukatja language, centred on the *stomach* as the seat of human emotions. ● For example, *'miyalu-kari'* (literally, other-stomached) describes a person in a state of low-spiritedness, that is, a person who is depressed, dejected, or *down-at-heart*, as the English idiom goes. In the Warlpiri language, *miyalu raa-pinyi* (literally, 'to open up one's stomach') means to make someone happy, as, for example, in the sentence: *'Ngulaji miyaluju raa-pungu, wardinyarramanu-juku'* ('He opened my stomach, he made me happy'). (Swartz, 2001:82). This could be compared with the English expression; *'He (or it) gladdened my heart, made me feel good or happy'*. ● It is clear that while the actual *experience* of sexual desire and falling in love may not differ greatly from culture to culture, 'the language of love' may be very different.

● While the stomach is the principal seat of the emotions , the *throat* ('waninja') is the primary location of *sexual* love and attraction. Amorous feelings, sexual yearning and attraction are all located, deeply felt and experienced as occurring in the throat (as opposed to the heart). Falling in love is described as *'waninja-nyinami'* (an emotion that is literally 'throat-sitting' or 'throat-located'). For this reason special significance is attributed to necklaces and other bodily adornments worn about the neck, close to one's throat, and such decorations are often used in ceremonies pertaining to love. Often these are woven out of hair string and used in *yilpinji* ceremonies. It should also be noted that they can be worn for a range of other purposes, including that of avenging a relative's untimely death. ● Warlpiri men use spindles to spin the hairstring or hair rope utilized in *Yilpinji* ceremonies. The spindle therefore has a special significance in *Yilpinji* art. In this context, the spindle is used exclusively by men: women are not permitted to lay eyes on this object, such is its potency. For this reason, no photograph of a spindle can be provided in this book. Personally, I would not dare to look upon one. ● Up until relatively recently representations of spindles in publicly exhibited *Yilpinji* visual art have been quite rare. Even today, many Australian Indigenous artists prefer not to include specific reference to spindles, or the act of manufacturing hair or hair-string for the purposes of Yilpinji. They either omit reference to this, or depict the paraphernalia associated with it in an indirect, vague, blurred, 'fuzzy' or coded way, which is apparent in some of the reproductions in this book. ● In the context of Central and Western Desert visual art, there is a major exception to this hesitation to represent the spindle in an upfront manner. In a number of his artworks Clifford Possum Tjapaltjarri explicitly represents this object. In her recent M.A. thesis, Mary Rivett (see reference list) has expertly mapped recent changes in the level of explicit depiction of spindles and related love magic objects in *Yilpinji* art at Yuendumu, surmising on the possible reasons for this apparent rupture with the past. Rivett concludes that it seems that this is as much about social change, and pressure from the dominant culture, as it is artistically motivated. ● LOVE AND MARRIAGE IN WARLPIRI AND KUKATJA SOCIETY *Love and marriage go together like a horse and carriage* – or so the Frank Sinatra song goes. But this is not the case in Warlpiri and Kukatja societies. In fact, free choice of marriage partner is a relatively recent phenomenon even in western cultures (*pace* Romeo and Juliet). Even today so-called 'free-choice marriage' is practised in relatively few of the world's cultures. In most societies marriage is a form of economic exchange, or another form of transaction between families. This has been most certainly the case among Indigenous Australians, but is less so today because of the influence of the European culture on Indigenous cultures. Likewise, polygamy in Indigenous Australian societies has become less prevalent than it was two or three generations ago.

● The Warlpiri and the Kukatja recognize full well the inherent instability of love as an emotion. That they understand the potential volatility of this emotion is demonstrated in their cultural invention *Yilpinji*, in all of its manifestations, visual, oral and aural. Romantic love and marriage are therefore, for the most part, separated in Warlpiri and Kukatja societies. At least, this was the case until not so long ago. ● How exactly are *Yilpinji* enacted? About men's ceremonies I have no knowledge. Women sing *Yilpinji* in all-women groups when one of the women wishes to attract a male lover. There is always a specific lover in mind, and this secret is shared only with members of one's one gender. ● Whilst singing the appropriate song cycles, women paint specific *Yilpinji* Dreaming designs on their chests and upper arms, designs that have the purpose of seducing the object of affection. The 'love magic' of the songs and paintings are considered too potent for the opposite sex to be exposed to their direct force – it could make them ill, or even kill them. ● *Yilpinji* have the potential to wreak havoc, if people do not follow the implicit rules. Many of the prints reproduced in this book are visual expressions of *yilpinji* pointing to the dire consequences of 'love magic' that has been abused for reasons of personal sexual gratification, where the rules of engagement have been broken. Such out-of-control sexual behaviour is strongly condemned in Warlpiri and Kukatja societies. Indeed, many of the prints represented here have associated Dreaming narratives providing advice on how human beings should *not* act, as well as nodding in the direction of desirable behaviour. ● Amongst Warlpiri and Kukatja people the ultra-taboo, illicit sexual relationship is that which occurs between a son-in-law for his mother-in-law, or *vice versa*. In normal circumstances, a mother-in-law and son-in-law should avoid one another completely, not even looking at one another or interacting in any direct way. Such sexual liaisons are deeply offensive to the strict rules of Indigenous kinship structures. For the Indigenous peoples of the Central and Western Deserts, the 'love that dare not speak its name' is sexual love between a son-in-law and his mother-in-law. Many of the *Yilpinji* prints in this book relate to this shocking theme. ● Certain *Yilpinji* may be glossed as "men (and sometimes women) behaving badly" specifically in the sexual arena. In the western world, we have become somewhat reliant on the media to inform us about 'how not to behave' in terms of sex and gender relations. Many famous sexual scandals brought to light via the media come to mind – the Christine Keeler/Profumo affair of the 1960s in England; the more recent outrage surrounding The American President Bill Clinton and Monica Lewinsky business ("I did *not* have sex with that woman") are two illustrations.

● By contrast, Indigenous Australians use the vehicle of the *Yilpinji* Dreaming narrative and its interconnected expressions in dance, song and the visual arts to provide a similarly enjoyable *frisson* among 'audiences' as well as a vehicle for condemning improper sexual conduct. In turn, this facilitates education about what in fact constitutes 'proper' behaviour in the sphere of sexual relationships. ● In addition, Love Magic charms, spells and songs relate to the many 'different' Dreaming narratives on which Yilpinji works are founded. The artworks include stories about objects that 'hold' powerful love magic, or relay information about gifted 'singers' of love magic (some good, some evil). *Yilpinji* may be abused as a form of sorcery and many of the works here make reference to that cultural malpractice. Other works in their narrative forms relate to young and innocent love, or are expressions of long-term faithfulness in love relationships and the virtues of nurturing and respecting the object of one's love and desire. The narratives include reflection upon the terrible consequences of uncontrolled sexual passion and the human tragedies that arise from this. ● Paintings, prints and other visual imagery can be understood as concentrated versions of these much longer oral narratives. All of the Yilpinji works in some way relate to the theme of love, or love magic (*yilpinji*) in the Warlpiri and Kukatja contexts and reveal a rich repository of cultural knowledge about this subject. Mostly, but not exclusively, they relate to transgressive love; the abuse or misuse of Yilpinji. However, there are also depictions in this book of Yilpinji relating to young, innocent, morally upright love. All of this is significant because it introduces the non-Indigenous world to a fascinating but previously little-known aspect of Indigenous social and artistic life. ● DO OTHER CULTURES HAVE PRACTICES SIMILAR TO *YILPINJI?* Some other Indigenous cultures in the world engage in practices that have the intention of luring a member of the opposite sex for whom they feel a powerful sexual attraction. For example, in the Japanese context, the tonkori, a beautifully resonant five-stringed traditional Ainu musical instrument made from the tendons of deer, had a range of different purposes: to control the elements, the forces of nature, by subduing fire, as well as wind, rain and hail and to hypnotize their enemies before the onset of battle. Ainu women also sometimes used the resonating tones of the tonkori for the purpose of seducing men (Otake, 2005:9). ● The Japanese custom of Yobai ('night crawling' for the purpose of having sex with young women has some manifestations in visual art form. Yobai continued well into the twentieth century in Japan, and children born from Yobai would be raised by the entire village.

● In Japanese visual art, the man practising enacting the Yobai is often depicted as a falling star – deftly falling out of the night sky into the futon of precisely the young woman he sexually desires! However, at best tonkori and Yobai, and other cultural customs constitute limited parallels. For example, seduction by tonkori seems to have been practised only by women, and Yobai seems to have been the exclusive province of men, as at least as the active party seeking the sexual liaison. ● There is no evidence of young women deliberately plummeting into the futons of sexy young man after dark, and having their way with them, whereas *Yilpinji* is practised in roughly equal measure by both genders. ● It seems not to be possible to identify examples of cultural practices with precisely the same intent as *Yilpinji*, or that are 'multi-media' in nature, in the way *Yilpinji* are. *Yilpinji* involve, in common with all other traditional Australian Aboriginal art forms, painting, singing, music, oral narratives and dance. As such, *Yilpinji* could be described as an ancient form of totally integrated "performance art". ● So, the dominant culture's notion of Indigenous 'love magic' is essentially a dumbing-down of a complex set of Indigenous social, cultural and artistic practices, that collectively warrant deeper exploration and analysis. '*Yilpinji*' artworks and their related narratives provide a window though which we, as outsiders, can glimpse the complexity of certain aspects of Indigenous Law and cultural mores. ● At the same time, we are able to admire the sheer beauty of these works by great Indigenous artists whose artistic accomplishments give us grounds to rethink Australia's past – and redefine the present and our collective future.

In 2002, when I was approached by Michael Kershaw from the Australian Art Print Network, and Adrian Newstead from Cooee Aboriginal Art in Sydney, to suggest a theme for an exhibition of a series of Indigenous art prints from the Warlpiri settlements of Lajamanu and Yuendumu in the Northern Territory and the Kukatja settlement of Balgo (Wirrimanu) in Western Australia, I quickly settled on that of *Yilpinji*. In a decade of living at Lajamanu, first as a linguist, then as the school's Principal, I had become very involved in Warlpiri ceremonial life, and participated in many women's ceremonies, including *Yilpinji*. In the face of my initial scepticism, the latter, incidentally, were successful in attracting the object of desire. ● In addition, curating an exhibition of *Yilpinji* works provided the perfect opportunity to try to redress some of the historical misconceptions about Indigenous 'love magic'. ● Adrian Newstead and Mike Kershaw contracted master printmakers Basil Hall and Theo Tremblay to travel to Balgo, Lajamanu and Yuendumu to collaborate with older, recognized artists on the theme of *Yilpinji: Love, Magic and Ceremony*. In turn, I agreed to curate the exhibition. ● This cross-cultural collaboration resulted in a remarkable series of limited edition prints by Indigenous Old Masters, involving most importantly, the Indigenous artists themselves, but also remote art centre staff and community organisations, a fine art print publishing house, several anthropologists with specialist knowledge of these cultural groups, as well as these two respected non-Indigenous printmakers. ● Since then, the exhibition has toured most states of Australia , as well as Canada, the United States, England, France, Sweden and Denmark. The exhibition is still touring the world, and visitors have demonstrated a fascination not only with the artworks but also with the Dreaming narratives underpinning them. The majority of images in this book are reproductions of works from this exhibition. ● As Mary Rivett states: *[This] print collection is significant because it tells Indigenous love stories belonging to Warlpiri and Kukatja people that had not been brought together before as a coherent whole.* (Rivett, 2005)

ABIE JANGALA was born in the bush near Thompson's Rockhole, about 350 km south of Lajamanu. After the war he joined his family at Yuendumu, an Aboriginal settlement for the increasingly displaced Warlpiri population, and later he moved to Catfish, a settlement further north. He lived at Lajamanu from the early 1950s and was a ceremonial leader of his community. He became a painter in 1986 and after this his work was exhibited in group shows in Australia, the USA and Europe. Jangala said that he painted the way his father wanted him to paint 'as he comes to me in dreams'. Abie Jangala died in 2002. BAI BAI NAPANGARTI is a senior law woman and Aboriginal artist from Balgo Hills, a long-serving member of the Kimberley Land Council and a strong practitioner of women's law and culture in Balgo. Her land extends from Mankayi in the Stansmore Ranges to just south of Yagga Yagga. She began to paint in 1986. She has travelled extensively for cultural reasons and in 1989 danced at the Shinju Matsuri Festival in Perth. ELIZABETH NYUMI lives at Kurrurrunku (Billiluna), an outlying community from Balgo. She lived in the bush with her family group before walking into Old Mission with her father after her mother had died from a dingo bite. She learned domestic skills and worked at stations around Billiluna. She married Palmer Gordon, now a senior law man of the Billiluna community. Her paintings are mainly concerned with her country and the abundant bush food belonging to her family. She began painting in 1989.

As a child EUBENA NAMPTIJIN lived with her extended family and travelled on foot through the sandhills of their Kukatja/Wangkajungka homelands in the Great Sandy Desert. She began painting with her second husband in 1981 and, over the years, has produced works in collaboration with other Aboriginal artists. She is now better known as a solo artist, working at the Warlayirti Artists Cooperative in Balgo, Western Australia. She is a senior law woman and ceremonial leader, and the major Dreaming sequences depicted in her work relate to Ancestral Women, Two Men Dreaming and The Seven Sisters Dreaming. HELICOPTER TJUNGARRAYI is from the Balgo Hills region of Western Australia. In addition to being a successful artist, he is a traditional healer, and people travel long distances to see him for treatment. In the early 1990s he painted with his wife, the late Lucy Yukenbarri, but since her death in 2003 he has painted solo in a distinctive linear style, depicting his country and that of his parents, where he lived a nomadic life as a young boy. He also uses the kinti-kinti style of dotting pioneered by his wife but works with a different range of colours combined with more flowing linear elements. JUDY MARTIN NAPANGARDI was born in 1940 in Lajamanu, in the Tanami Desert region of the Northern Territory. She paints using acrylic on canvas and screenprinting, often depicting women and rock wallabies. Her work has been exhibited all over Australia as well as France, the USA and Canada.From the Tanami

Desert region near Yuendumu in the Northern Territory. From the Tanami Desert region near Yuendumu in the Northern Territory, JUDY WATSON NAPANGARDI is one of the most accomplished and prolific painters of the Warlukurlangu Artists group at Yuendumu. Most of her works depict Mina Mina, an important women's Dreaming site from and her homeland, as well as Dreamings connected to it – women, digging stick, snake vine, honey ant, native truffle and hair string belt. With her sister, the late Maggie Napangardi Watson, Judy has developed a distinctive style that contrasts lines of colour with richly textured surfaces. She has participated in many group exhibitions in Australia and overseas. LIDDY NELSON NAKAMARRA began painting in 1986. Using large, expressive, iconographic forms in bright colours, she depicts subjects from her Dreamings, such as small snake, yam dreaming and bush grapes. Her works express an unrestrained quality that is typical of the style of artists from her community in Lajamanu, in the south-west of the Northern Territory. Her brother is the artist Michael Jagamarra Nelson. LILY HARGREAVES NUNGARRAYI is a senior law woman responsible for supervising women's song and dance ceremonies in her local community of Lajamanu. She began painting in 1986, and her subject matter focuses largely on the themes of medicine/snake vine, wallaby and women's Dreaming. She takes a different approach to other artists of the region who apply dots in a random fashion, instead employing dotted lines to create heavy, textured backgrounds.

Her work is held in a number of private and public collections, and she has exhibited throughout Australia, France and the USA. From the Balgo Hills region of Western Australia, LUCY YUKENBARRI was a respected senior custodian during her lifetime. She possessed a vast knowledge of the waterholes of the Great Sandy Desert, and she depicted many of these soaks and rockholes in her art. She began painting in 1989, just 14 years before her death at the age of 69, and her early works followed standard Balgo Hills methods of forming rows of dotted lines. As her work developed, she began using a different technique of single colour fields of dotting, later going on to paint her dots so close together that they converged, creating dense masses of pigment on the canvas. This gave her work a distinctive style that was unique in Aboriginal desert art, but has since been emulated by many others. MOLLY TASMAN NAPURRURLA lives in Lajamanu and is a member of the Warlpiri language group. She began painting in 1986, producing works of mixed media painted on cardboard, and later using acrylics on canvas. Her art depicts Dreaming stories associated with her surrounding country, such as seed, marsupial mouse, tree, snake and wallaby, and the style of her work is close in origin to the designs applied on bodies during women's rituals. She has exhibited throughout Australia, the USA and France.

PADDY SIMS JAPALJARRI lives at Yuendumu in the Northern Territory's south-west, where he is one of the community's leading artists. He has a vast knowledge of traditional practices, and he teaches Dreaming, painting, hunting, traditional dancing and bush tucker at the Yuendumu school. In 1986 Paddy was involved in portraying the Dreaming stories on the the Yuendumu doors (now known as the Yuendumu Doors project), which led to the proliferation of artistic activity in the area. His work has appeared in numerous national and international exhibitions, and in 1988 he was chosen to travel to Paris with five other Warlpiri men to create a ground painting installation at the Centre Georges Pompidou. PADDY STEWART JAPALJARRI lives in Yuendumu and is currently the chairman of the Warlukurlangu Artists Committee. As a young man he worked on stations around the Northern Territory and as a cook in Papunya, and he has also taught painting, Dreaming, tracking, dancing and other traditional practices at the Yuemdumu school. Like Paddy Sims Japaljarri, he took part in the Yuendumu Doors project in 1983 and was selected to create a ground painting installation with five other Warlpiri men (including Sims) at the Centre Georges Pompidou in Paris in 1989. Born at Parwalla in the Tanami Desert, ROSIE TASMAN NAPURRURLA has exhibited work throughout Australia, Europe and the USA. Her traditional country, Miya Miya and Parwalla, and the Dreamings associated with these sites, provide the inspiration and imagery for her distinctive paintings. She was introduced to the medium of acrylic paint in 1986 when the first works from Lajamanu were created for a public audience, and since then, painting has played a fundamental role in the ritual and ceremonial life of her family. Both of her siblings and her daughter are established artists in the Lajamanu community. SAMSON MARTIN JAPALJARRI is a Warlpiri artist from Yuendumu in the Northern Territory. He paints with acrylic on canvas, as well as screen printing, and the many subjects depicted in his art include eagle, possum, bush onion, kangaroo, goanna, two men and native cat. He was one of five Aboriginal artists from Yuendumu to be included in the international touring exhibition 'Yilpinji, Love, Magic and Ceremony' in 2003. His daughter Andrea Martin Nungarrayi is also a celebrated artist, who frequently paints Yilpinji subject matter. SUSIE BOOTJA BOOTJA's works tell stories about playing at the waterhole of Kaningarra, where she spent her youth. As a teenager she moved to the old mission at Balgo, where she worked in the kitchen. She was one of the first women to begin painting at Balgo, one year after her eldest son, Matthew Gill, started up the Balgo art centre in 1985 with Sister Alice Dempsey. Susie's art is well known for her dual use of Western and traditional representations of country, and for her lively use of bright greens, pinks and sky blues. Her innovative dotted colour fields began in 1996 and she continued to develop her style each year up until her death in 2003.

TEDDY MORRISON JUPURRULA began painting in 1986 and is now a senior Aboriginal artist in the Northern Territory's Lajamanu community. His paintings and screenprints depict the Dreamings of his country (Miya Miya and Marlungurru), which include seed, bush louse and hawk. His works have been exhibited around Australia, as well as in Europe and the USA. He is the brother of Molly Tasman Napurrurla and Rosie Tasman Napurrurla. From the Balgo Hills region of Western Australia, TJAMA (FREDA) NAPANANGKA was a senior law woman with an intimate knowledge of her country. She began painting in 1988 and her work is intricate, with a strong legacy of tradition. She was also an accomplished dancer and teacher of traditional culture, and was involved in many committees concerning Aboriginal and women's issues. Her work has been exhibited widely in Australia and overseas. TJUMPO TJAPANANGKA was born at Muruwarr, north of Kiwirrkurra in Western Australia. He moved to Balgo some time around 1948, at a time when the missionaries were encouraging Aboriginal people to move to the old mission. He is still based in the Balgo Hills region, and is a highly respected senior law man, healer and artist. He began painting in 1986, and his works are recognised by their bright colours and tightly concentrated lines that swirl about the canvas. Tjumpo's works have been exhibited nationally and internationally, and are included in collections in Australia and overseas.

UNI MARTIN NAMPIJINPA is a Warlpiri artist from Yuendumu in the Northern Territory. He was born in 1932 and began painting in 1980, working mainly with acrylic. Among subjects he depicts are Wurlukurlangu (fire), Yankirri (emu), Ngapa (water) and Pamapardi (flying ant). His works are in many collections, including The National Gallery of Victoria, the South Australian Museum, the Australian Museum and the Musee National des Arts Africains et Oceaniens, Paris. RONNIE LAWSON JAKAMARRA was born at Rilyi-rilyi before 1930 and is Pintupi/Warlpiri. He started painting in 1986 and liked by everyone at Lajamanu for his sweetness of disposition.

NAKARRA NAKARRA I – SEVEN SISTERS DREAMING *continued from page 16* The Seven Sisters (the Nakarra Nakarra) are forever destined to flee this lustful, immoral man, a kind of bogeyman figure who seeks physical gratification for his uncontrolled, transgressive sexual love. While he never catches them and never fulfils his illicit desires by having his way with them, the sisters can never rest. They must eternally flee through the sky pursued by man, who is the Morning Star. There are many interesting things about this Tjukurrpa or Dreaming narrative. For instance, in terms of cross-cultural crossovers, interestingly enough in Greek mythology this cluster of brilliant stars is also thought to comprise seven sisters, believed to be the seven mythical daughters of Pleione and the legendary Atlas. It also reveals Indigenous people's detailed knowledge of astronomy as well as the strict moral codes within which they operate. There are many different versions of this Seven Sisters Dreaming narrative throughout Aboriginal Australia that are sung and painted - for example, the story and artistic representations of it extend as far south as the Ngarrindjeri people of the River Murray in South Australia. This particular Kukatja version encapsulates classic Yilpinji elements wherein people derive a kind of guilty pleasure at the "wrong skin union" but only as a kind of spectator sport that is ultimately condemned and socially outlawed in no uncertain terms. Furthermore, in the case of the Nakarra Nakarra Dreaming based near Wirrimanu (Balgo) Western Australia, women have particular rights and

responsibilities in relation to the narrative and paintings whereas in some other Australian Indigenous societies men may have greater custodial rights. Balgo-based ceremonial leader Eubena Nampitjin provides a fine example of the Nakarra Nakarra Tjukurrpa in her work.

RAINBOW MEN *continued from page 20* During ritual re-enactment the Rainbow Men embody the alluring attributes that can make a woman leave her own country despite her fierce attachment to it and follow her man far away from her own land. In ceremonies such as these, men imitate the sparkling, bedazzling qualities of the Rainbow Men by wearing shiny belt buckles or carrying pieces of broken glass, which shimmer and reflect the sun. These are qualities that attract women during ceremony just as women cover themselves in red ochre rubbed into animal fat so they themselves glisten and radiate good health in order to attract a man.

NAKARRA NAKARRA II – SEVEN SISTERS DREAMING *continued from page 18* This particular Kukatja version encapsulates classic Yilpinji elements wherein people derive a kind of guilty pleasure at the "wrong skin union" but only as a kind of spectator sport that is ultimately condemned and socially outlawed. Furthermore, in the case of the Nakarra Nakarra Dreaming based near Wirrimanu (Balgo) Western Australia, certain women have particular rights and responsibilities in relation to the narrative and paintings whereas in some other Australian Indigenous societies others may have greater custodial rights. Balgo-based ceremonial leader Eubena

Nampitjin provides a fine example of the Nakarra Nakarra Tjukurrpa in her work. NGARLU JUKURRPA – LOVE STORY DREAMING *continued from page 58* These people turned into Miinypa, native fuschia flowers, which are prevalent at Ngarlu today. When Lilipinti and his Napangardi made love, his penis broke off inside of her and they both turned to stone. There is a rockhole at Ngarlu which shows the place of their love-making. They are seen in the rocks at Ngarlu, a long water hole with a broken boulder reminds the people of this union. Wapunungku, a big tree, was crying. That tree is still there today. The kirda (owners) for this Jukurrpa are Japaljarri and Jungarrayi men and Napaljarri and Nungarrayi women. WATI KUTJARRA *continued from page 64* The two boys thrived, growing to healthy manhood, all the time plotting to take their revenge on their father. The print is a visual depiction of an event which takes place much later in the Wati Kutjarra Dreaming sequence, when the two young men are fully grown. After some time the two, who by now were young men, put their plan into action. They visited their father's brother, another Tjungarrayi, who lived some distance away and managed to convince him that their father intended to prey upon and steal that particular brother's wives. The brother, outraged, crept up on the boys' father and, at close range, threw a boomerang at him with great force, almost fatally wounding the man, who did however manage to retaliate, eventually killing his brother. This sequence of events, or this 'original sin", if you like, acts as a catalyst for a further whole chain of significant Dreaming events. The narrative also acts as a moral template, in which the importance of observing marriage laws is stressed. In oral versions, for example that of Peggy Rockman Napaljarri, the depiction of the transgressor's punishment for breaching the Law figures prominently. As a result, the two sons (or Two Goanna Men, now the Dreaming Ancestors for so many Indigenous peoples), took off, travelling over great tracts of desert country, going in and out of the ground at various places, creating natural phenomena, and drinking from rockholes and soakages and leaving traces of their presence in the landforms. As Lee Cataldi has written, the sons 'become the culture heroes of a whole cycle of myths concerning the Two Men. A major sequence of the Two Men centred around a place called Yaka Yaka which includes typical culture hero activities as teaching people to use fire and and cook their food'. Apart from the fact that there is not one baby boy, but two, later to become the 'Two Men' of this Dreaming, there are a number of uncanny parallels in this Dreaming to the story of Moses in the Christian Bible, and some echoes of the Oedipal drama as well.

Yilpinji – Love, Magic and Ceremony
Stories continued

MADJARDI – HAIRSTRING PUBIC BELT, WOMEN'S
LOVE MAGIC *continued from page 28* When the man
approaches she entices him with her charms until he
comes under the influence of her allure. She reveals
the belt as his ardour grows and persuades him to place
the belt around her waist. As he does he falls under her
spell and they go off together in to the long grass to
make love. Once their love is consummated they walk
off into the bush together as a couple. Other important
Warlpiri people, on learning of their tryst, follow them
and confront them as a couple. In this way the group
recognises their relationship and acknowledges that it
is an appropriate match. They are now recognised by
all as a couple.